Modern Artists

Agam

Harry N. Abrams, Inc., Publishers, New York

Günter Metken

Agam

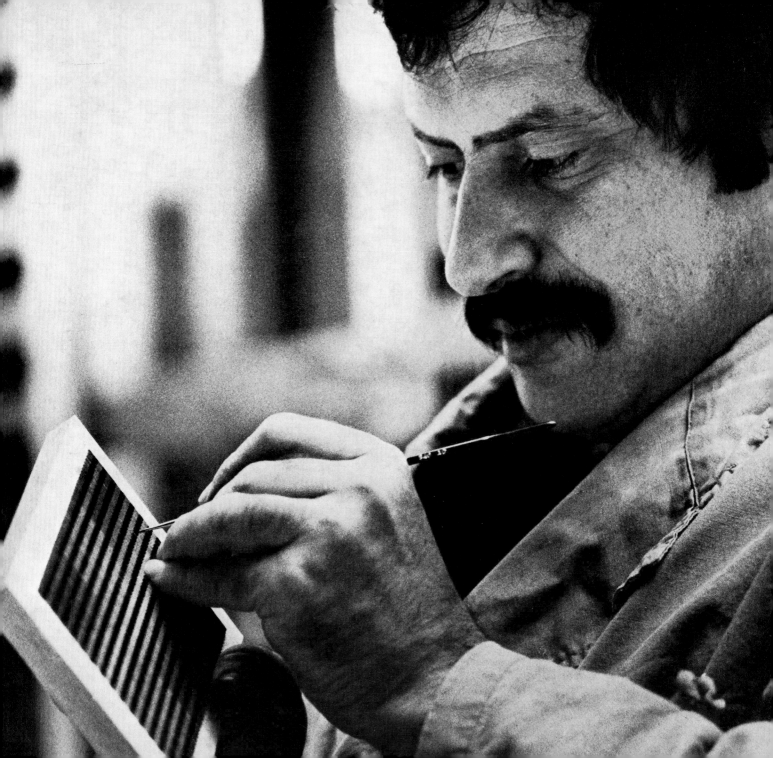

Yaacov Agam's studio has the air of a modern research institute—a laboratory of ideas. The emphasis is resolutely placed on the future. The artist shows the visitor transformable paintings and sculptures, electric lamps that react to breath impulses, an apparatus to mass-produce soap-bubbles. The mental attitude behind all this dynamism is a highly contemporary interpretation of the Second Commandment: "Thou shalt not make unto thee any graven image, or any likeness of any thing that is in heaven above, or that is in the earth beneath, or that is in the water under the earth." Likenesses are invariably static and repetitive; Agam's art, like life itself, is in constant flux. Ancient Jewish precept and modern thinking meet on common ground in his work.

Yaacov Agam exhibited his earliest kinetic sculptures in 1953 at the Galerie Craven in Paris. This show was probably the first anywhere to be devoted strictly to kinetic art. Agam was represented by 45 pieces, which ran the gamut of all the various modes he was to develop further in years to come; it was like a catalogue of the possibilities open to kinetic art.[1] In 1954 he exhibited three important pieces in the Salon des Réalités Nouvelles, and in 1955 took part with Bury, Calder, Duchamp, Mortensen, Soto, Tinguely and Vasarely in the "Le Mouvement" show at the Denise René Gallery, which proved to be the definitive exhibition for the kinetic movement. In the sixties Agam's work was included in all the large exhibitions of kinetic art, which had become a firmly established tendency. In 1963 Agam, representing Israel at the Biennale in São Paulo, was awarded a special *ad hoc* prize for artistic research.

In twenty years of work Agam has succeeded in overcoming the limits of traditional two-dimensional painting. Unlike more specialized Op and kinetic art, his work is accessible to a wide audience because it activates the public and encourages it to participate. Individual concentration is replaced by collective participation. The static image, fixed in time, gives way in his work to the changing pattern, capable of indefinite renewal. Agam is out to change both our psychological and physical attitudes to art. Art, as he would say, should not be dead and immutable but alive and capable of expressing all the complexity of a world in which events are not successive but simultaneous. In these works the spectator himself acquires a role and a function. The appeal is to all his senses; and it is through him that virtualities become reality.

Following the dictates of an internal logic, Agam's work over the years has been an endeavour to create architectonically integrated images and mutable sculptures which serve to define virtual space. His latest work still deals with problems formulated in his earliest experiments. His goal has always been to release the creativity of the art public, to encourage people to enter into the spirit of his work and change it according to their tastes. In Agam's work, art, usually a monologue, becomes a dialogue; each composition theoretically possesses not one but an infinite number of pictorial solutions. Agam has had to overcome a great deal of resistance to his ideas. Public commissions serve to give concrete shape to the theories of a man who champions a totally new approach to visual education. In everything he does, this openness is apparent; Agam has definitely turned his back on the traditional conception of art as immutable and timeless. His is work in progress, work in which change, not finish, becoming rather than being, is the key.

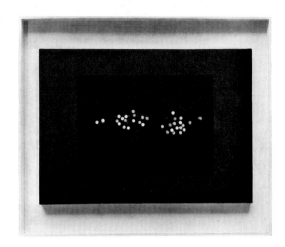

Night 1953

Escape from the Image

Agam's work marks the beginning of a movement centered in Paris which has devoted itself to transcending the boundaries between media and has introduced the elements of time, space and light into art. The vehicle of this revolution is metamorphosis in time, expressed in two forms: imitation of movement and optical irritation. [2] Agam desires something more: to escape once and for all from the fixed image and to shake off all formal and thematic categories. In this he sees important parallels to his own work in the puzzle-portraits of Arcimboldo (1527–93), whose ambiguous images alternate between detail and whole depending on how they are read; in the drawings of the Venetian artist C. M. Mitelli (1634–1718), reversible heads that show a different but complete physiognomy from both angles; and in the anamorphoses of Renaissance art, distorted images which become legible if viewed from a certain angle. This interest in pictorial ambiguity brought Agam's early work close to that of the Surrealists; if the viewer has to read the image into the work, he thus becomes a participant in the artistic process. Another important consequence is the upsetting of familiar patterns to form a looking-glass world full of unfathomed possibilities. Agam's first *Transformable Pictures*, which the viewer can rearrange, lay emphasis on the aleatory principle which questions accepted notions of art. It is thus that a number of Surrealists have detected in Agam the promise of a transcendence of rigid reality. Robert Lebel organized the seminal exhibition at the Galerie Craven in 1953; Max Ernst, Jean Arp, and Victor Servranckx bought works by Agam; and Victor Brauner was an attentive observer of his development. Agam was in close touch with André Breton, who made generous efforts after the Second World War to bring young artists and new tendencies under the banner of Surrealism. It was natural that he should see Agam's pictures as a means of testing the public's psychic attitudes.

Agam brought painting out of its long isolation and into renewed contact with dynamic forces in all areas of life, making change the rule rather than the exception. It is at this point that one can best understand Agam's disagreement with the conventional interpretation of kinetic art and its origins.

These origins can be traced as far back as Georges Seurat's attempts to do in painting what men like Muybridge and Marey did in photography, to capture the body's movement in phases. Perhaps the best-known example of this is his *Le Chahut* (1888–90). At about the same time Claude Monet was painting haystacks and Rouen cathedral at different times of day and under different light conditions. Though the paintings in these series were meant to stand alone, the eye inadvertently springs from one to the next in an attempt to see them all at once. The eye and mind seek a whole that is always just out of reach. Our perception, accustomed to more solid ground when looking at art, begins to waver.

In the early years of this century, the Italian Futurists followed similar paths towards overcoming the static character of painting in an attempt to integrate it into a world which was just beginning to be dominated by the fruits of technology. Bound as the Futurists were to figurative images, they could hope only to freeze the phases of movement in time and space. Only an art which eschewed content and recogniz-

Transformable Relief 1953

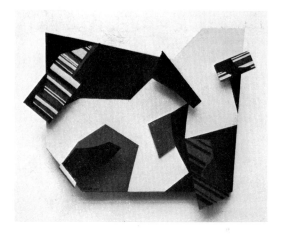

6

able subject matter could hope to express the new consciousness of time and space which emerged from the philosophy of Henri Bergson, who saw time as an irreversible series of events each of which meant the world created anew. Time for him meant time lived through, *durée réelle*, in contrast to the calibrated time continuum of physics; no thought could enter a man's mind more than once, simply because at every point in time thought is colored by the memory of things past. Albert Einstein's theory, in a highly simplified version, was also influential in defining space and time as relative to the parameters of location and velocity.

These two theories were first distilled for the purposes of art by Naum Gabo and Antoine Pevsner in 1920. Their *Realist Manifesto*, after denouncing color, static imagery, contour lines and naturalistic subject matter in art, announced: "We greet a new element in the visual arts, kinetic rhythms, as the basis of our perception of real time." Gabo's *Steel Spring* of 1920, driven by a motor and tracing virtual curves in space, was a first move towards mobility; Gabo himself never followed it up, but it was accompanied by related experiments by Man Ray, Marcel Duchamp and others. However, there was no attempt at structural transformation, such as exists in Agam.

But this is not the place to describe the very complex process that led to the kinetic art of the mid-century.[3] Yaacov Agam's position in the modern context is the important thing. He points to the insights of atomic physics, particularly the identity of energy and matter, as crucial to his experiments, the goal of which is to replace the static confrontation of viewer and painting with an irreversible flux of experience in the Bergsonian sense. The observer is to become a participant who is free to choose the final composition from a number of possibilities offered, but without having the freedom to suggest a completely new solution: his activity takes place within the bounds of a theoretically limited number of permutations, a planned whole. This is Constructivist art raised to a higher power, because it includes the spectator as an active creative force. We will return to this point in our discussion of Agam's sculpture.

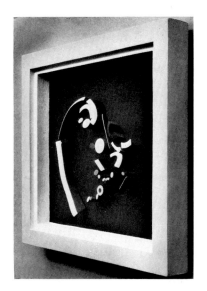

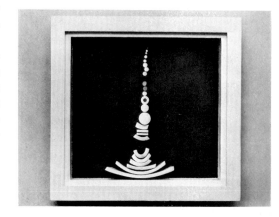

Dibuk, 1955

Time-Space Continuum and Dynamic Color

A number of experiences combined to prepare Agam for his disruption of the concept of the picture. The son of a rabbi, he stresses that the Jewish religion lays emphasis on the present and the future as constituents of an irreversible stream of experience. While he was a student he was imprisoned by the British as a member of the Jewish resistance movement. It was the contact with his fellow-prisoners that awakened him to the necessity of an open, dynamic and universally accessible visual language.

Agam began his studies at the Bezalel art school in Jerusalem. He studied with Mordecai Ardon, who as Max Bronstein had attended Johannes Itten's preliminary course at the Bauhaus and also studied there under Klee and Kandinsky. From 1929 to 1933 he had taught at Itten's art school in Berlin. On Ardon's advice, Agam went on at the end of 1949 to continue his studies at the Kunstgewerbeschule in Zürich under Itten. He also went to lectures by Siegfried Giedion and studied art history and

composition theory at the university. Giedion's ideas attracted him;[4] as is well known, their basis lies in the mathematician Hermann Minkowski's suggestion, made in 1908, that the universe should be thought of as four-dimensional, because time and space, rather than being separate entities, merge into an indivisible continuum. For Giedion every era of history was an identifiable whole; ours was characterized by an inadvertent parallelism in scientific and artistic methods which was leading to an inevitable and spontaneous balance. Max Bill, whom Agam also met in Zürich, saw things on similar lines, emphasizing that geometric abstraction was a historical phase in painting. For him the ideal artist was a kind of visual engineer whose job it was to throw light on the complexity of invisible processes.[5]

The ideas of the painter and color theorist Johannes Itten also strongly influenced Agam while he was in Switzerland. Itten's teacher, Adolf Hölzel, had postulated "laws of experience" that defined the psychological effects of color in terms of a musical analogy. He began by analyzing our purely physical reactions to colors and the role the mind plays in our perception of phenomena such as simultaneous contrast. Itten gave these thoughts, basically those of a practitioner of painting, a theoretical underpinning with the aid of the color theories of Goethe, Bezold and Chevreul. Philipp Otto Runge's "color sphere" of 1810 interested him particularly because it emphasized our psychological reactions to different color combinations. Itten remarks that for him seeing a painting was like being reborn: "Perceiving form means being moved, and being moved means creating form. Even the subtlest feeling is a form that radiates movement. All living things reveal themselves to man through movement. Everything moves and nothing is dead; otherwise it would be nothing."[6] Similarly, Itten differentiates between what he calls color reality *(Farbwirklichkeit)* and color effect *(Farbwirkung)*. The expressive possibilities of color are inextricably bound to the expressive values of form.

Revolution in Seeing

By the time Agam reached Paris in 1951, a reaction was just beginning to set in against the subjective lyricism of Tachism and the European gestural school of painting. More rigorous in approach, more contemporary, more "realistic," as Agam was later to say, the new movement took the work of the Neo-Plasticists and the *Cercle et Carré* group as its model but exceeded it rather quickly. Malevich and Mondrian supplied the icons, Kandinsky and Klee in their writings the catechism of the new movement. Alberto Magnelli and Auguste Herbin were among the first to work out artistic solutions of a high order.[7] Their dynamic and luminous arrangements of space were in direct line with the early breakthroughs of Frank Kupka and Robert Delaunay. Eschewing personal style and literary content, the simple symbolic language developed by these Paris artists in the early fifties was meant to be accessible to as wide an audience as possible. In the beginning Agam sympathized with Lewasne, Mortensen and Poliakoff. Their goal was the kind of extension of visual experience that Josef Albers had pursued (in two dimensions) in his painting and

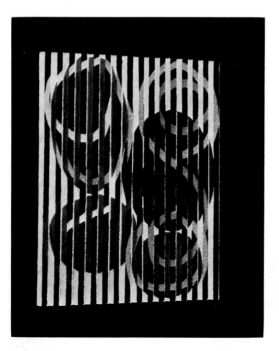

Unity, Evolution from the Point to the Line 1961

8

teaching: "The spectator remains uncertain—he is incapable of deciding in favor of one interpretation or the other. He may momentarily prefer one and may make an effort to concentrate on it. But as soon as this concentration diminishes, the picture offers him further, indecisive structures."[8]

This is the case with Albers's *Structural Constellations*, "which vary from one to the next in internal structuring, making the image's gestalt seem to differ from painting to painting."[9]

An Art to Participate In

Agam does not take optical purism so far; he discards static experience in favor of the dynamic. He often requires from the viewer not only perceptional but physical participation, as in his plug-in and movable paintings, tactile reliefs and variable sculptures. Agam's work involves all the senses, not just the eyes; in the case of *Sensibility I–III* (1961; page 26), vibrating steel springs bring even the sense of hearing into play.

Agam's show at the Galerie Craven in 1953 included the seeds of most of his later inventions. Among the pieces that invited the public to step out of its passive role was *Structure*, with its rows of white rods to be twisted and turned on their black background to give a seemingly unlimited number of graphic compositions. The joy of discovering and playful freedom stimulate the viewer, and he chooses from all the combinations available the one that most pleases him. One's freedom to alter the piece seems as boundless as the number of permutations.

In pieces such as *8+1 in Movement* (page 11), *Melodic Line* and *Structures—White Lines on Black Ground*, Agam made use of a wide repertoire of rods to be twisted or plugged in. The science department at Montpellier University possesses a wall composition which amplifies these early systems. Completed in 1971, it consists of eighteen identic vertical panels on each of which are mounted the eight elements; these can be rotated in place or their positions changed on the board (page 48, below). The result is a series of both quantitative and qualitative permutations that evoke the students' work in mathematics. In *Night* (page 5), rods capped with colored wooden balls are plugged into a black perforated board. The number of possible constellations rivals that of the night sky.

Hitherto more like simple games than anything else, Agam's compositions began to take on interesting nuances with *Dialogue*, a 1954 piece in which irregular shapes of various sizes appear for the first time, or with *Design in Relief* (page 14), in which the plug-in markers take the form of triangles, rectangles, trapezoids, spirals—in short, the whole vocabulary of geometry. Agam's movable pin game is at its most fascinating in his *Signs for a Language* (page 15). Here the small colored blocks are emblazoned with symbols, dots and fragments of the alphabet, like a kind of abstract Scrabble. The symbols, shorthand for a universal theory of combinations, can be placed singly, in groups or in horizontal or vertical lines: they represent a visual alphabet. This game has seen many versions all of them based, on Agam's favorite

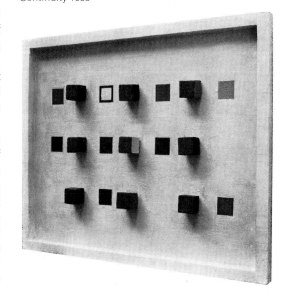

Continuity 1953

idea—a contrapuntal alphabet with word-chords located on parallel horizontal lines like those of sheet music, "each of which would express a feeling, a sensation or a thought and whose simultaneous systems would express as completely as possible the psycho-physical state of a person at any particular time."[10] The experiments of concrete poetry in juxtaposing words, phrases and sentences irrespective of content are paralleled in this phase of Agam's art.

In spite of their seeming naiveté these early works contain the essential elements for Agam's later development: point *(Night)*, line *(8+1)* and form *(Dialogue)*. In *Dialogue* the forms converse with each other and with the spectator, and visual forms express the discourse. *Design in Relief* connects relief and space.

Mutable Painting

Agam's movable, mutable paintings serve a different purpose, as suggested by the name of one of the early reliefs in this series, *Revolution of Established Forms* (page12), in which the key word could mean either revolving or revolt. *On Black Ground* (page 13), *White and Black on Black* and *Continuity* (page 9), with their geometric shapes in black or color on a dark ground, show Agam's intentions even more clearly. Equal forms create new relations. Agam's purpose here is evident. In the interests of finding a more direct approach to the art public and destroying the painter-viewer dichotomy, he chose the geometric language of non-object art. This is pointed up by *Dibuk* (page 7), a piece Agam played variations on later in *Truth in Curves* and *Infinite Continuity*, which encourage the viewer to create his own composition with a selection of typical plug-in shapes. One is reminded of Tinguely's *Meta-Kandinsky*, *Meta-Malevich* and *Meta-Herbin* of 1954–55, in which pictorial elements typical of these painters are motorized in order to give the art public a chance to create its own modern masters.

The title *Dibuk* (suggested by Breton) is that of a Yiddish legend play by Shalom Anski which the Habimah Theater staged with great success all over the world in 1917; it illustrates Agam's desire to transcend the boundaries between the arts and as on the stage to embrace the originally isolated elements—point, line, form. He has already successfully mixed aspects of painting, sculpture and kinetics and would like nothing better than to add the colors and rhythms of theater and dance to the brew, to create an art that would rival even the space-time flux of film.

Polymorphism and Counterpoint

Agam began to bring these goals within reach in work done in the very productive years 1953 and 1954, work that today is central to his painting. He calls them "paintings in polyphonic superimposition" and describes them as follows:

"Several visual themes, differing in structure and color, interpenetrate and merge in counterpoint. The surface of these pictures consists of a relief of prisms mounted

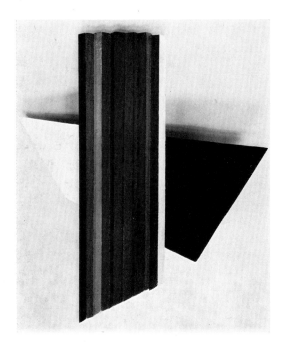

Transformable Relief 1953

10

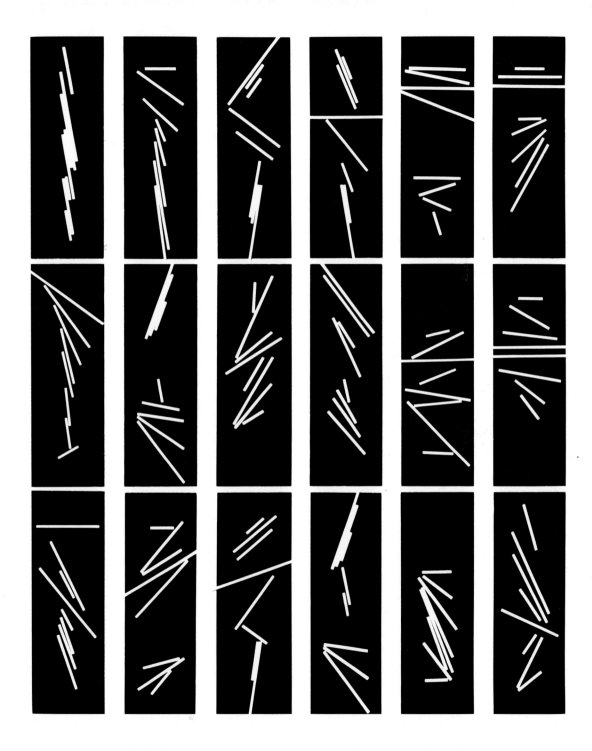

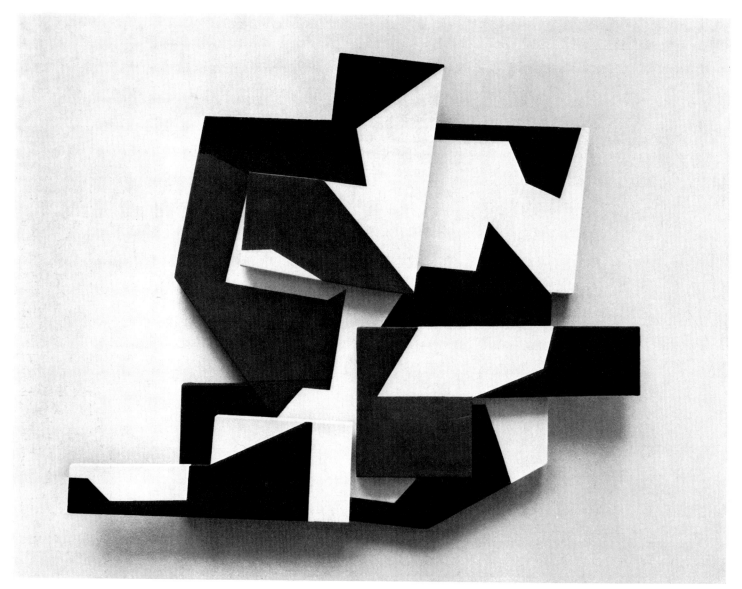

On Black Ground 1953

page 14: Design in Relief 1954
page 15: Signs for a Language 1953

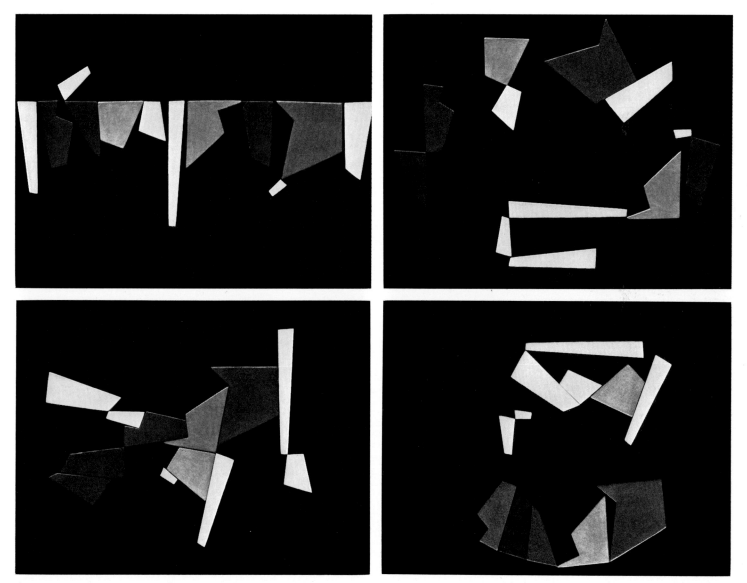

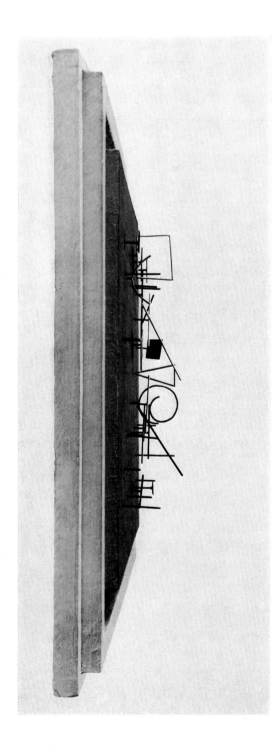

vertically and parallel to one another like a series of pointed waves, which gives a rhythmic system of measure into which the different themes are painted. I have succeeded in uniting as many as eight clearly differentiated themes in one work; you can see them integrated with one another when you stand directly facing the picture, and you can see how they slowly separate and then reunite when you move from right to left."

"I begin by painting a different theme on each of the parallel surfaces. Standing to one side of the picture, you see only the composition which is painted on the surfaces nearest you; the more you move towards the center, the more the second composition begins to appear and unite with the first in counterpoint. Seen directly from the front, the compositions come together to form a new whole, like orchestral music become visible. The content and formal characteristics of these compositions are modified and transformed by the domination of first one motif and then the other, in direct proportion to the change in the observer's standpoint in front of the picture."[11]

The frequency of expressions borrowed from music is interesting here; Agam also likes to compare the viewer's activity in transforming his mutable paintings to a musician's interpretation of a score. His choice of terms suggests that he had Bach's *Art of the Fugue* in mind; one of his later large compositions is entitled *Homage to Johann Sebastian Bach* (pages 30, 31). Musical speculation, some of it more vague than helpful, is a characteristic of Agam's writing, but he is quite clear in defining his primary interest as adapting mathematical and musical series, of the kind Max Bill also found in Bach, to the dynamics of his medium. The works activate the potential contained in the kind of folk art in which the same picture shows different images from different directions (as in devotional images showing Christ when seen from the left, God the Father when seen from the right, and the Trinity when seen from the front).[12]

Agam works in terms of contrast; two simple themes are played off against one another, in the manner of a fugue, orchestrated in a gradually richer and more open structure. Series he creates run up the color scale in equal intervals from dark to light, from circle to square, in the attempt to "create a painting that exists not only in space but in time, one that develops and unfolds and produces a number of plastic situations which can be determined ahead of time, situations that lead into one another and whose successive appearance and disappearance reveal ever new visual aspects."[13]

In *Three Movements*, *Life Arises where Opposites Meet* and *Plastic Fusion* (page 17) or *Melody* we are confronted with three different phases or views of the same image, whose shapes change position as we change our standpoint, but whose total number remains constant.[14] *Homage to Juan Gris* is a good example of the "double scoring" Kahnweiler found in the work of the Cubists, like a musical round with the second voice taking up the melody a few bars later than the first. In creating these fugues, whose forms advance or recede in space in accord with the intensity of their colors, Agam begins with two compositions, which, when seen from the side, are complete in and of themselves. Seen *en face*, the painted prisms throw a pattern of parallel 14

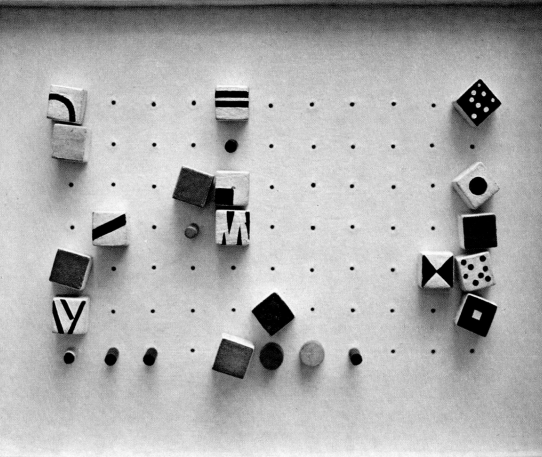

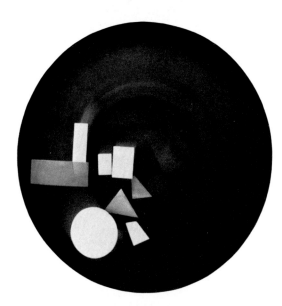

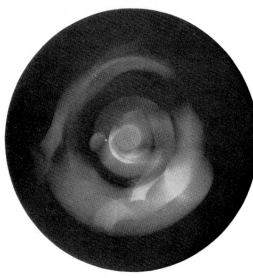

Movement in Transformation 1956

lines on the interlocking form progressions. Agam's method consists of dividing his overlapping combinations into two halves to create virtual diptychs that command a surprising amount of space, for they cannot be grasped as a whole from any one fixed point—experiencing them is a dynamic process.

Contrastasis

The space-time continuum as Agam had envisioned it was still missing from these paintings, which offered basically only a front view and two different side views of the same image. Other projects seemed to promise other and better ways of overcoming the stasis, the fixed viewpoint and the fixed axes of the traditional easel painting. He built rotating reliefs of wood (*Liberty*, 1957), suspended panels painted on both sides from the ceiling *(Painting in Four Dimensions)*, or screwed them to free-standing spring steel mounts (*Evolution II*, 1959; page 18), or set perforated discs with plug-in geometric elements in rotation (*Movement in Transformation*, 1956; page 16). This second idea went beyond the optical, mechanical kinetics of Marcel Duchamp's *Rotoreliefs*. But the *Space Reliefs*, with their steel elements inserted at various levels, were also discarded. The future belonged to a piece like *Aventure*, in which basic shapes were subjected to transformation by superimposing them on rotating or stationary discs. Now compositions with up to nine simple themes were a reality.

Cyclical Transformation

Agam has always made good use of the stockpile of forms built up over the years by all branches of non-objective painting—Neo-Plasticism, Suprematism, Constructivism and the rest. Many of his pieces are implicit homages to the pioneers of abstract art; his *Four Themes, Counterpoint* of 1958 takes up the grid of Mondrian's *Victory Boogie Woogie*. His *Unity, Evolution from the Point to the Line* (1961; page 8) opens out from left to right, in common with *Stages of Creation* of 1961 (page 24). In general, however, double reading—beginning from either side—is most common in Agam's work.

The vertical and horizontal ovals, truncated in the intermediate phases of the cycle, appear to the eye as complete forms in accordance with the gestalt theory of perception; only the camera can arrest the vibration of these paintings. Their virtual movement prevents us from perceiving them in detail, and the overworked eye, disappointed in its expectations, is placated with residual images.

From polyphony, multiple melody, Agam went on to meta-polymorphy, multiple form, which found its classical expression in *Four Themes, Counterpoint* of 1959 (page 25). Titles like *Cycle* and *Creation* emphasize the open-endedness of these migrations of form that lead the eye from left to right and back again in the search for a whole. A kind of cyclical *perpetuum mobile* results when Agam pulls all the stops. All thinkable combinations and contrasts come into play: light against dark, black and white against color, positive against negative, horizontal against vertical, point

16

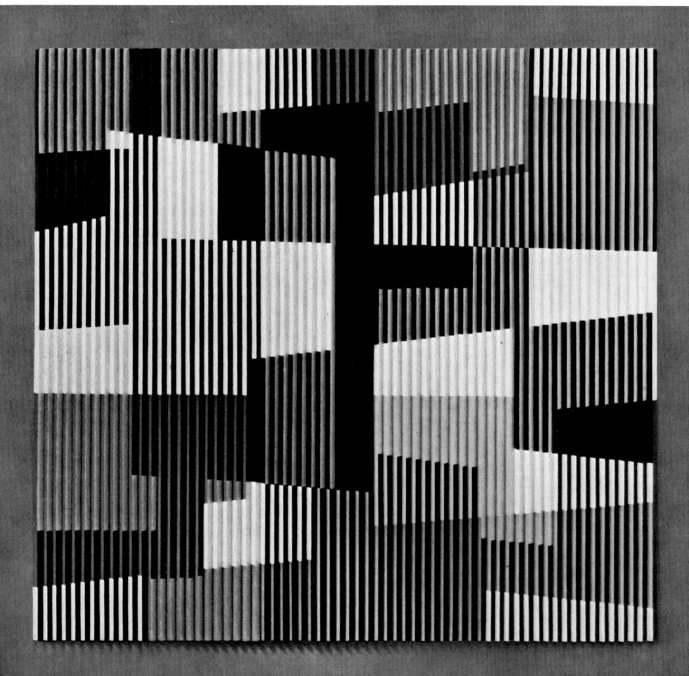

17

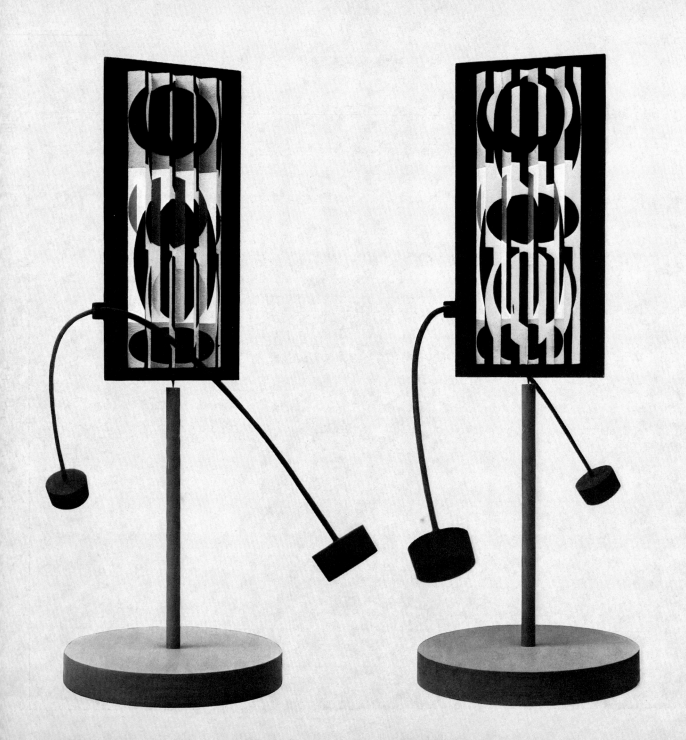

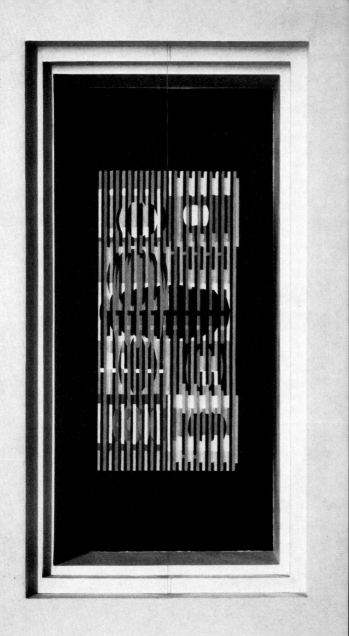
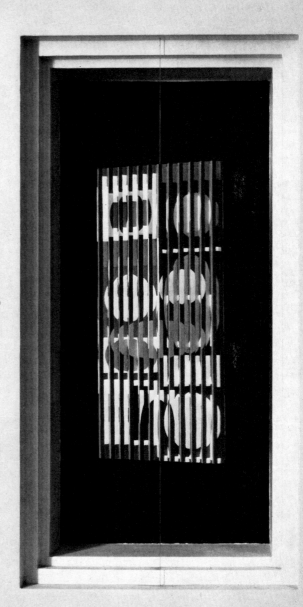

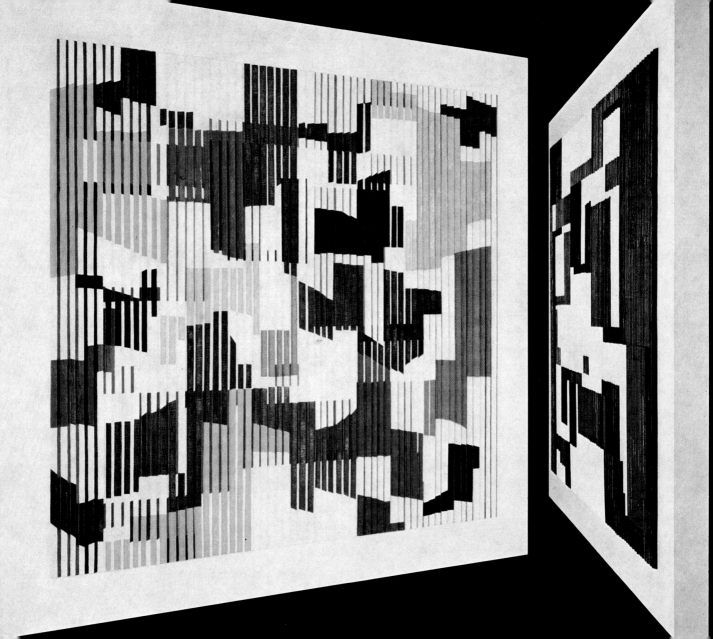

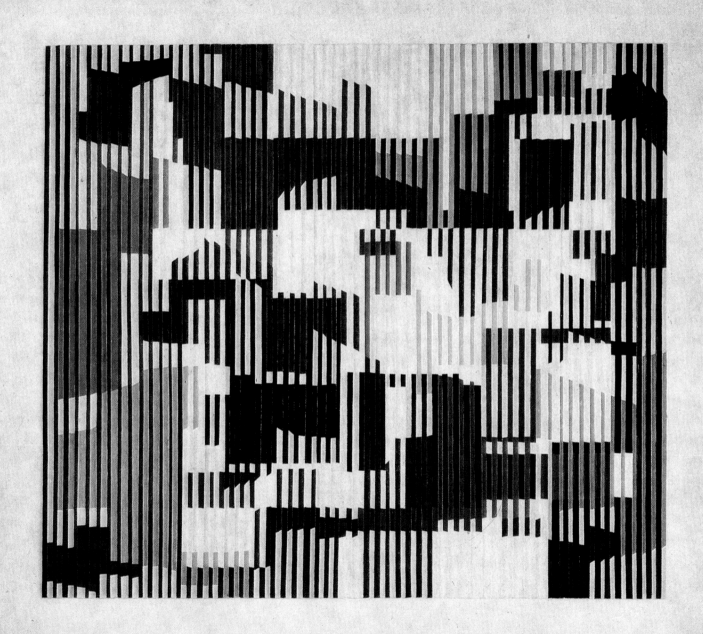

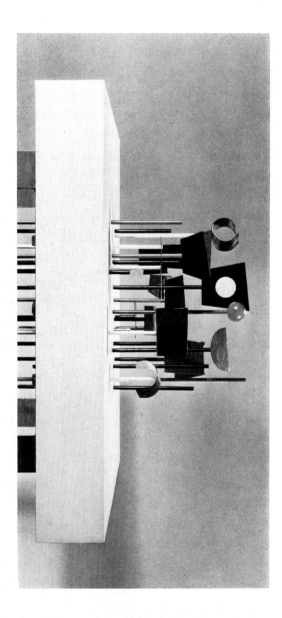

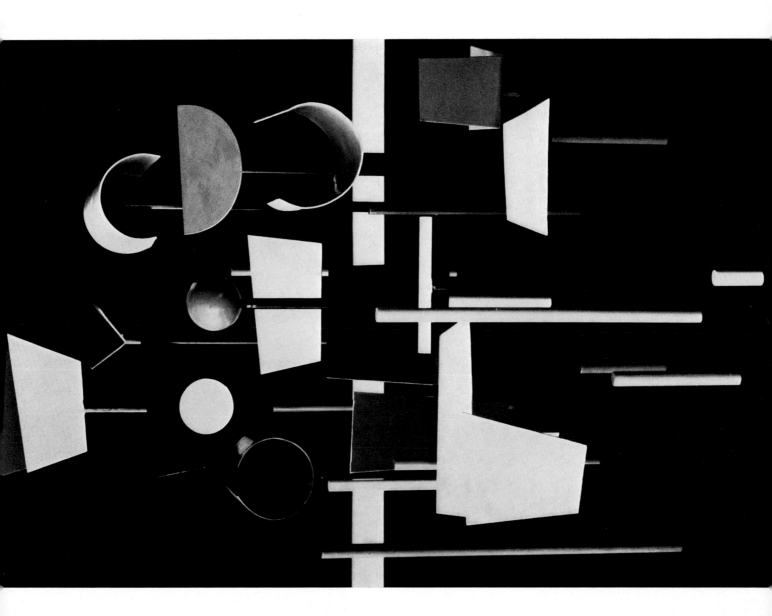

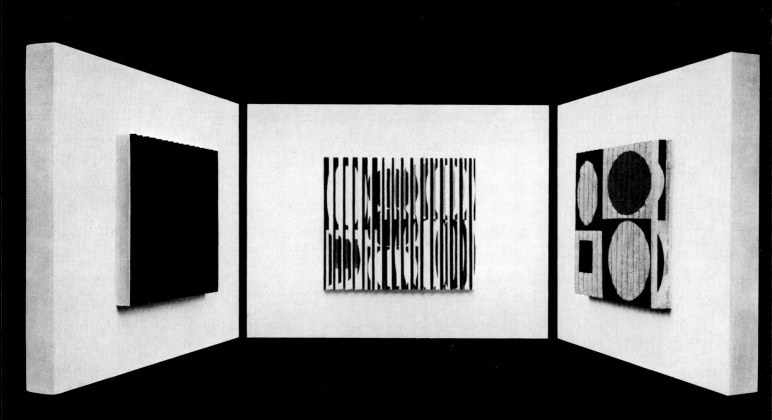

Four Themes, Counterpoint 1959

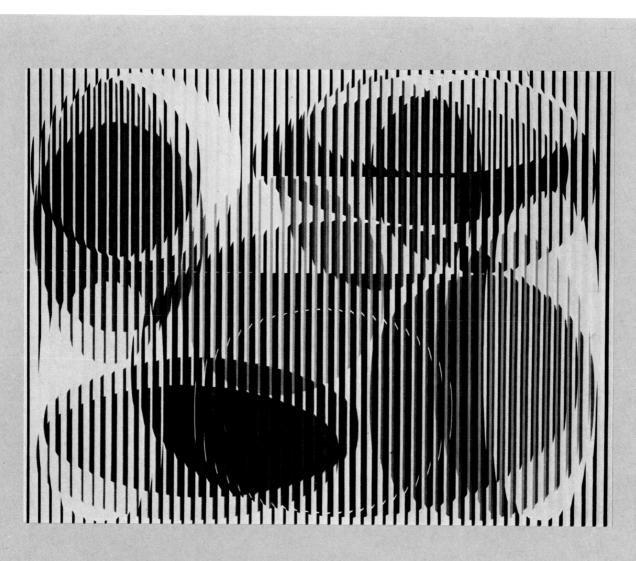

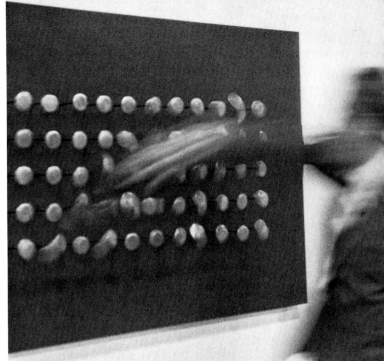
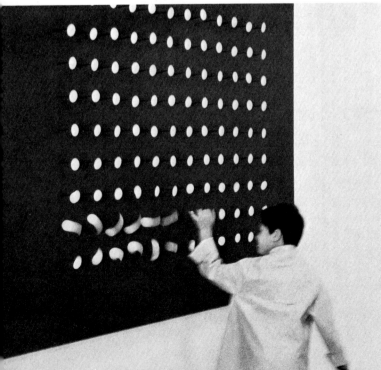
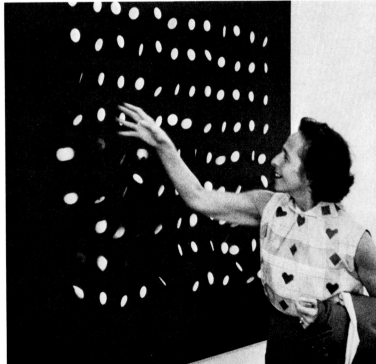

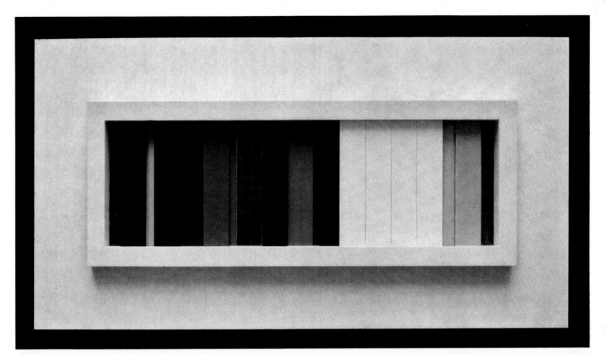

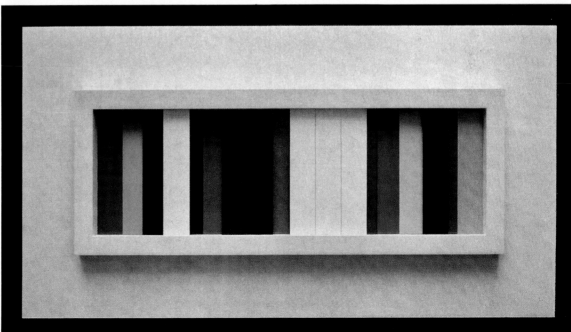

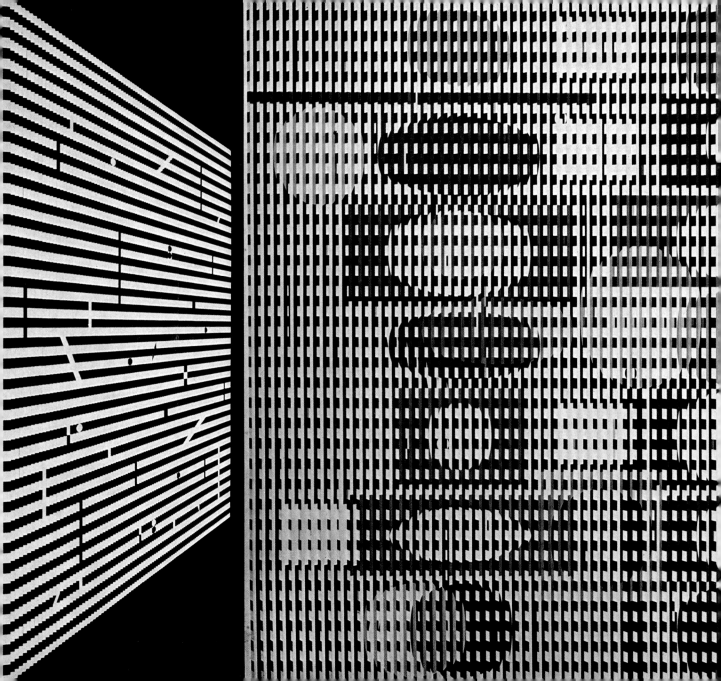

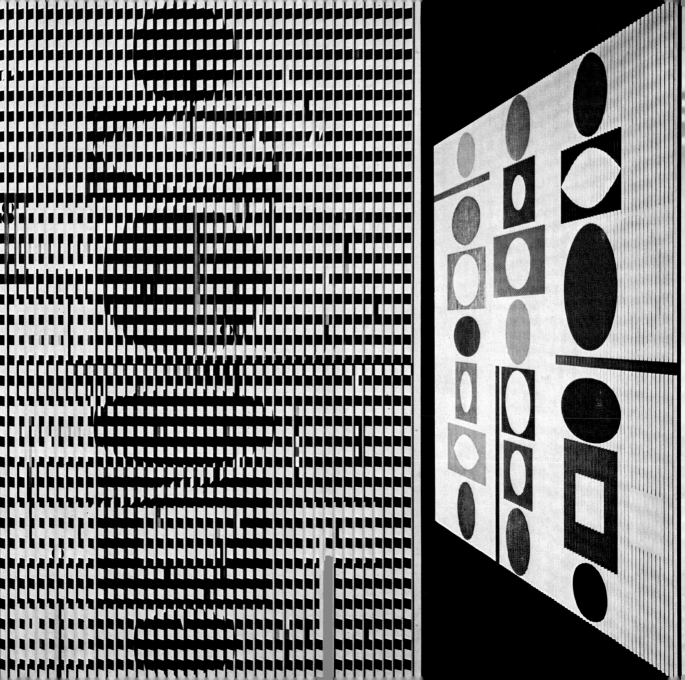

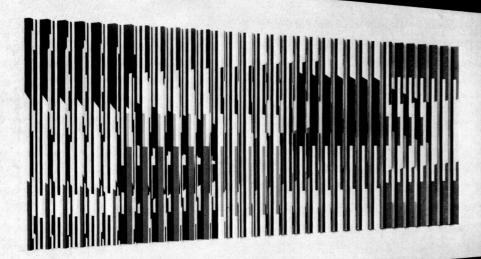

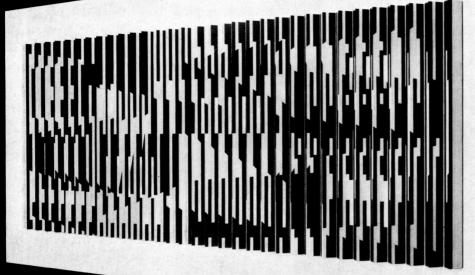

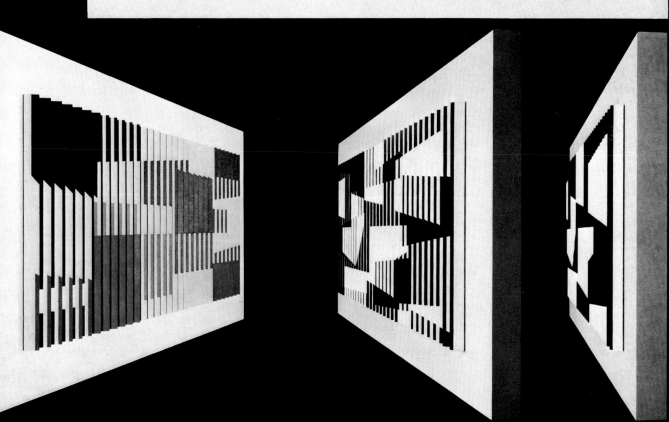

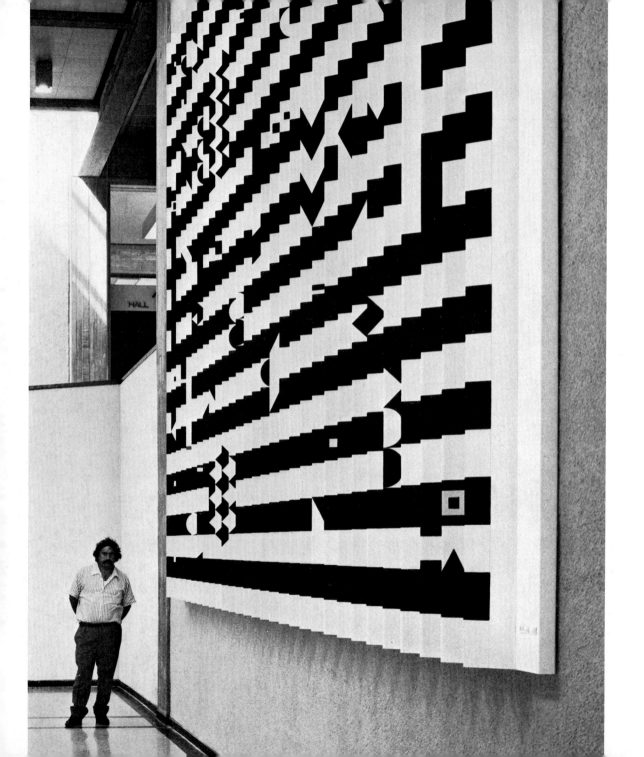

Time Step, 1971

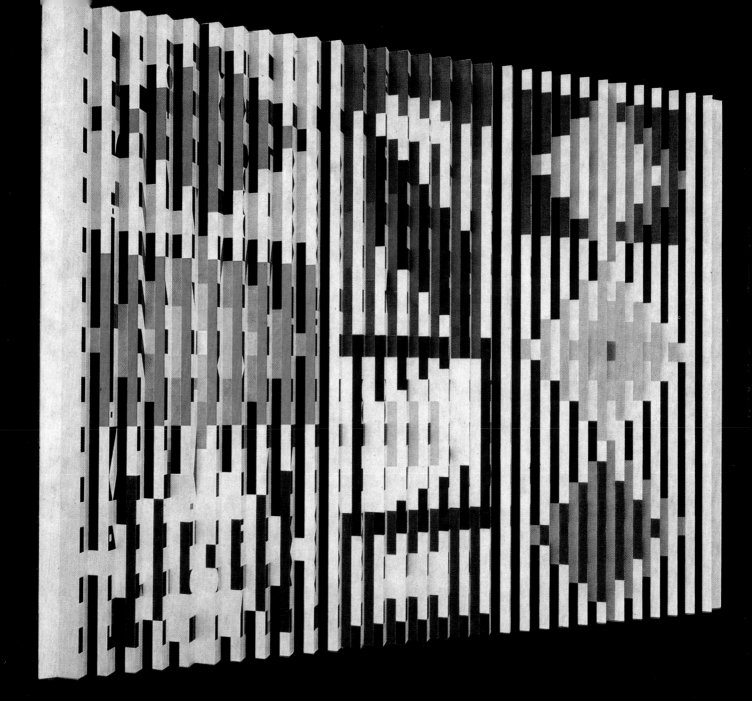

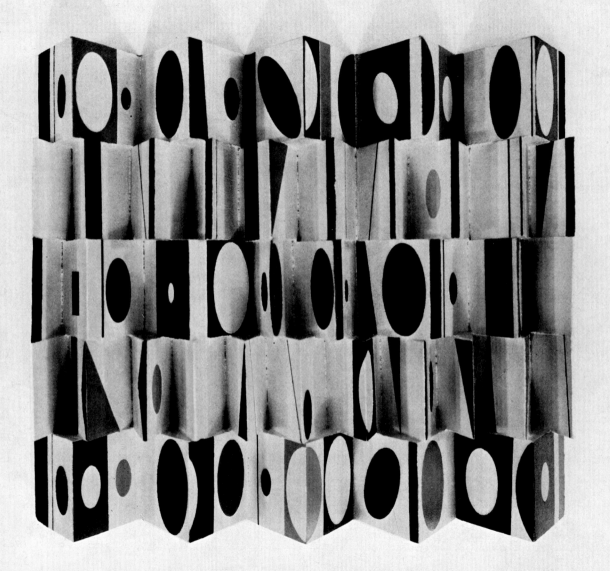

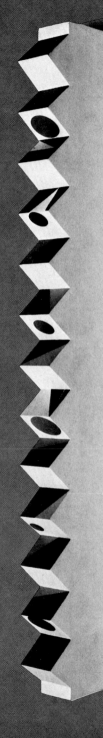

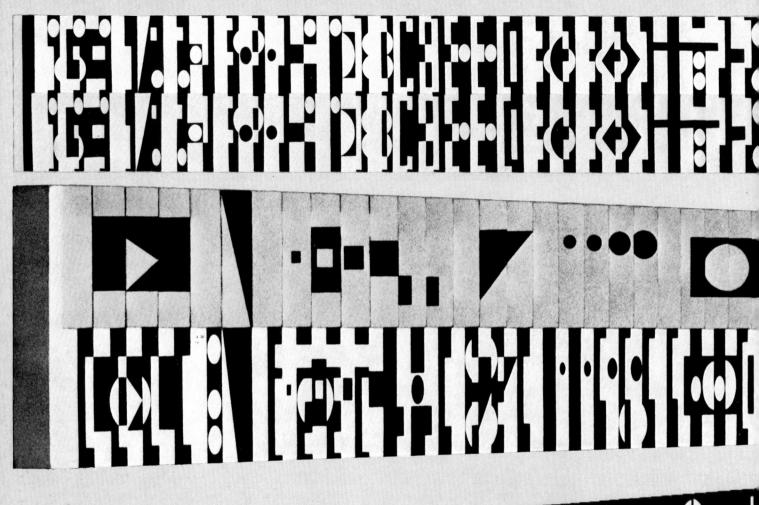
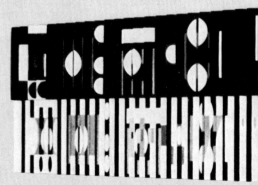

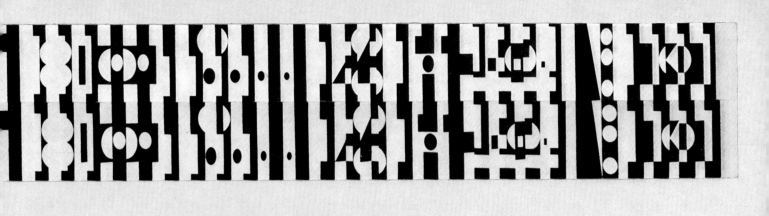

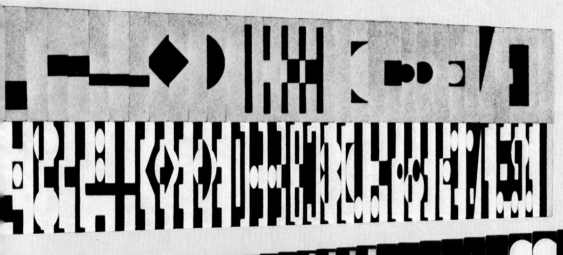

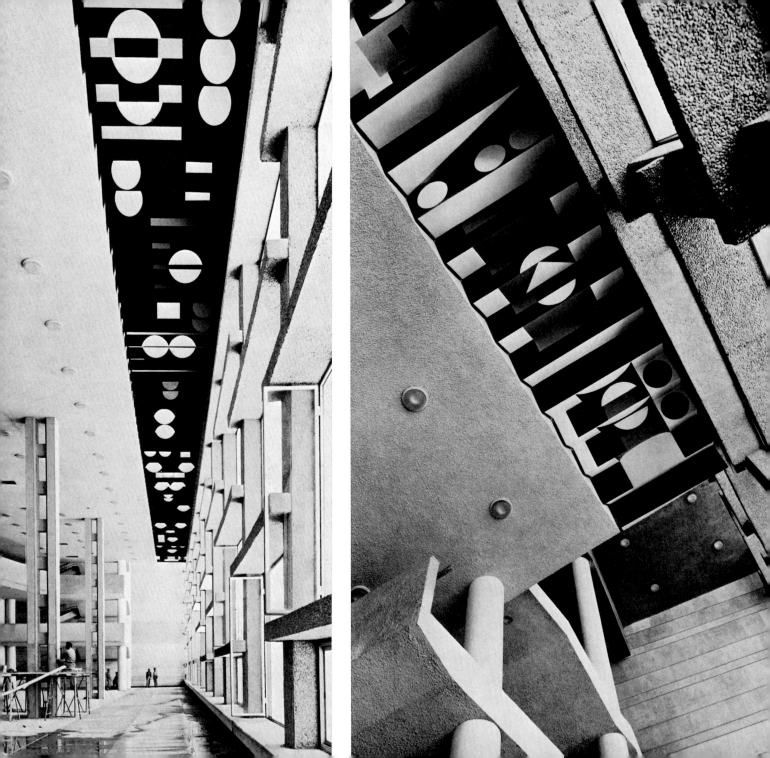

"And he dreamed, and behold a ladder set up on the earth, and the top of it reached to heaven; and behold the angels of God ascending and descending on it."

Genesis 28:12

page 34: Rhythmic Relief 1964
page 35: Painted Columns 1963–64
pages 36–37: Jacob's Ladder (Maquette) 1964
pages 38–39: Jacob's Ladder, Jerusalem 1964

against line. His visual orchestration becomes richer and richer; many paintings read black and white from one side and full color from the other. Or from the right we see a pointillistic pattern of rectangles, triangles, semicircles and zigzags, and from the left a series of large serene shapes composed of lines. Analysis and synthesis meet. Lately Agam has gone over to painting wavy lines on his louvers, in subdued colors edged in black on the one side and bright hues edged in white on the other—emotional color progressions that bring form to life.

Walls and Ceilings

Agam's work lends itself well to integration in an architectural context, and has proven its worth many times over in relieving the monotony of large modern buildings—convention halls, schools, even ships. A good example of this is the large *Double Metamorphosis II* (pages 28, 29) in the foyer of the Museum of Modern Art in New York. Perhaps even more effective in their contexts are the two pieces Agam executed on commission in 1964 and 1965, a painting for the former Israeli liner *Shalom* and a relief for the foyer ceiling in the National Convention Hall, Jerusalem.

Agam assigns these pieces a definite function: "They orientate and distribute the crowds." Because they cannot be properly appreciated from a fixed point, they channel movement in directions functional to the building or ship. The painting for the *Shalom* is called *Double Metamorphosis*, is 30 feet high and 20 feet wide, and consists of thirty thousand small square images. It is mounted facing the interior stairway connecting the three decks. Going up and down stairs the passengers see five contrapuntal themes appear, merge and disappear, both horizontally and vertically, giving the effect of an extensive space that, as Agam says, compensates for the relative confinement between the ship's decks.

This functionality is even more evident in the relief Agam executed for the National Convention Hall in Jerusalem, the largest building in modern Israel. The relief (pages 36–39) is 300 feet long and 12 feet wide, and is made up of 81 triangular prisms that run the length of the piece and are painted on two sides. Located in the first foyer on the ceiling over the long stairway leading up to the main hall, it is a fine example of the productive integration of art and architecture. Agam worked out the principle on a small scale in his *Painted Columns* (page 35), notched rails on which the motifs are painted in such a way that they separate into two parts when seen from a distance but merge and become more precise as one draws nearer.

Agam calls his ceiling *Jacob's Ladder*, after the episode in the Old Testament (Genesis 28:12) in which Jacob, his head resting on the holy Stone of Bethel, dreams of "a ladder set up on the earth, and the top of it reached to heaven: and behold the angels of God ascending and descending on it." Agam translates this metaphor into his own pictorial language: discs, blocks and triangles. People walking along the hall or using the stairs follow the steps of a kinetic ladder that opens up to one side in a light and the other in a dark progression, and are led to the large window that overlooks Jerusalem.[15] A second version of the *Ladder*, this time on a vertical wall, was installed in the palace of the President of Israel.

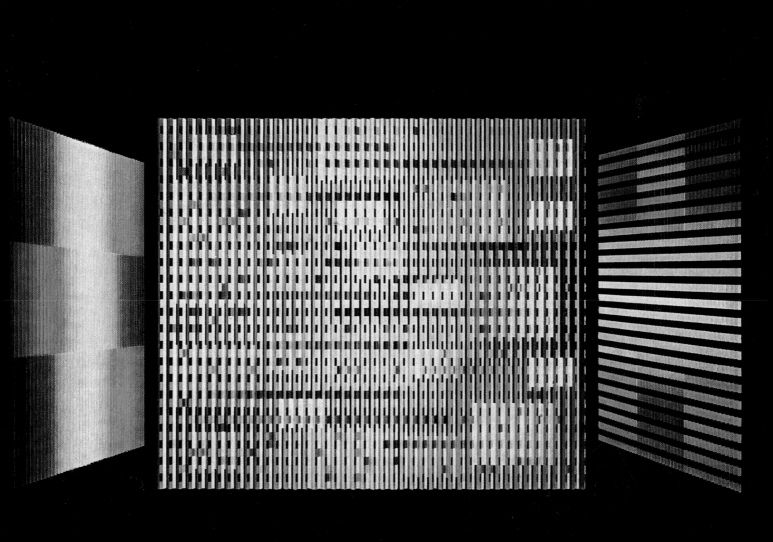

Multi-stage Theater (Project) 1962

Leverkusen Forum

One of the undisputed highpoints of Agam's work in kinetic painting is his contribution to the Leverkusen Forum, a cultural and communication center in Leverkusen, West Germany (pages 43–47). Executed in 1969 and 1970, this composition consists of a series of themes covering the walls of the hexagonal hall at the Forum. In a brochure describing the complex, the artist explains: "Up to now we have viewed paintings as if through windows. In this piece for the Leverkusen Forum I have created an artistic space which surrounds us completely and in which we exist. This space is different for everyone depending on the way he confronts it; it moves as the viewer moves and presents a different aspect from each angle."

The six paintings form a total optical environment. The eye sees each composition in a different phase of development. Thus the movement is twofold: not only does the kinetic frieze rotate, but the viewer's glance does, too, in the search for a totality always just out of reach. These two movements form concentric circles with different velocities. In Leverkusen Agam was offered the chance to try out a polyphony made up of polyphonies; this single room contains a great number of complex compositions, each of which enters the optical symphony at a different time and in a different rhythm. In pictorial terms, one experiences progressions made up of 354 hues, whole and truncated shapes, patterns and overlaps. For the compositions on two of the walls Agam used the pointillist technique (developed in the sixties) to render the surface polyfocal. Here orientation to a small number of themes and large shapes gives way to completely fragmented perception. Seen from the side, these surfaces seem to vibrate in an energy exchange. This pointillism represents perhaps the maximum of optical effect possible on a two-dimensional surface. The euphoria of the color progressions is communicated to the viewer, who is both creator and beneficiary of an enlightening aesthetic experience.

The Leverkusen conception might be compared to those Renaissance concerts given by chamber orchestras playing simultaneously in different corners of a room, leaving it to the audience to concentrate first on one, then on the other, in an effect of total stereophony. Above all, Agam's hexagonal environment reminds one of the theater-in-the-round shown in 1962 at the Musée des Arts Décoratifs in Paris (page 42, above).[16] To suggest the simultaneity of events in reality, the audience is surrounded on all four sides by stages, and the seats are mounted on swivels so the viewer can choose which play he wants to watch. Or the roles can be reversed and the theater transformed into an arena with the action in the center and the audience on the periphery. This idea is one of the latest in a long line of attempts since the turn of the century to intensify the communication between actors and their audiences.

With the help of a piece Agam did there in 1971, the congregation of the Park Synagogue in Cleveland can choose the precise lighting and mood of their meeting-hall (page 48, above). Colored glass discs mounted on the windows can be slid back and forth to give a continually changing spectrum of light. This sliding arrangement had first been used in 1963 in works such as *Evolution, White, Black, Color* (page 27). In 1972 Agam applied the same principle to the wall and ceiling decorations for the

Leverkusen Forum (Plan) 1970

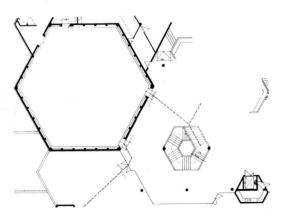

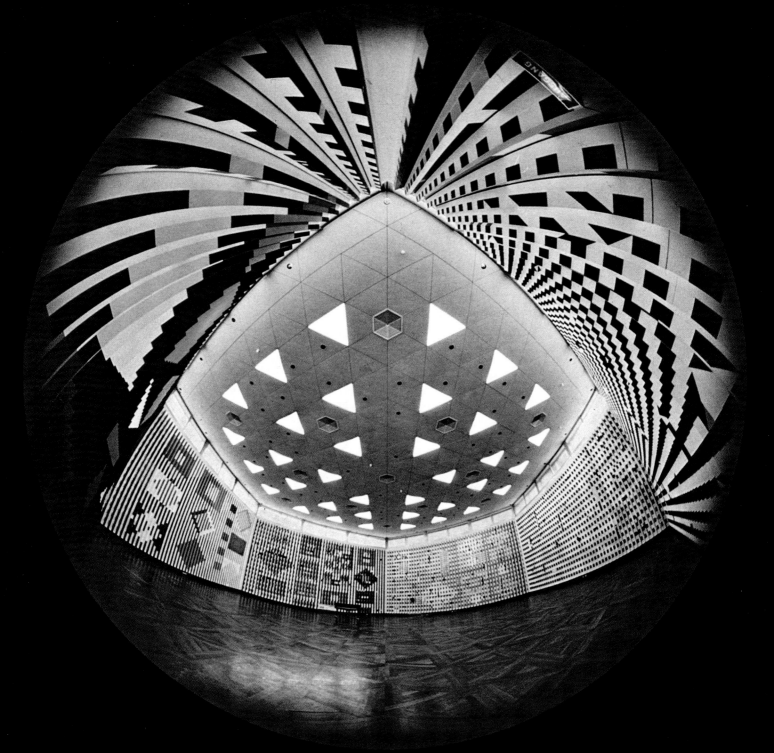

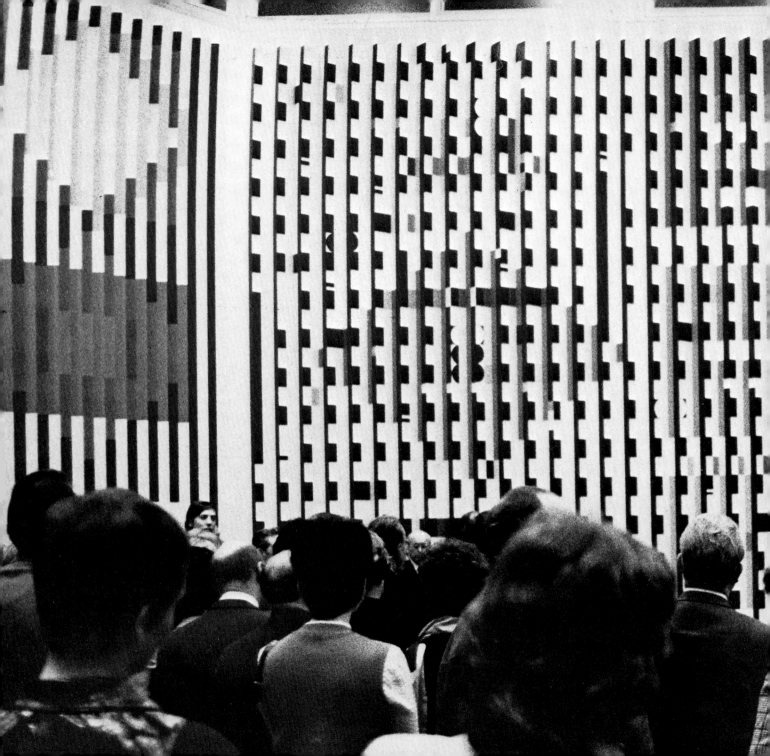

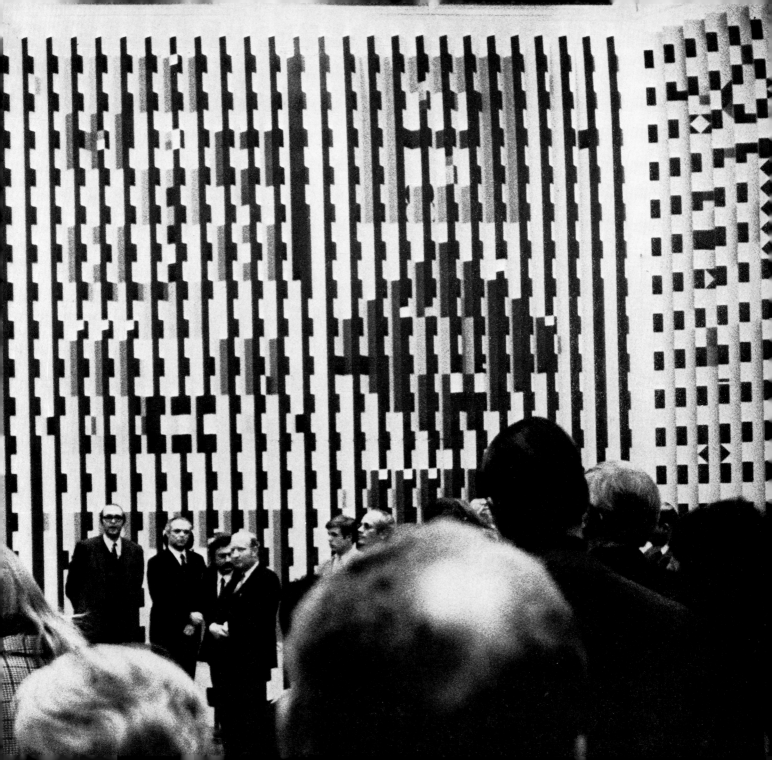

first salon in the Palais de l'Elysée in Paris, home of the President of the French Republic, and combined it with a kinetic wall similar to that at Leverkusen (page 49). The carpet there has a kinetic pattern, too, so anyone passing through the room is exposed to a myriad of optical effects.

pages 43–47: Leverkusen Forum 1969–70

Sculpture

The sense of touch has always played a role in Agam's art, as a facet of the complex multi-sensual aesthetic experience he desires to create. By means of it he has succeeded in involving his audience physically in his work, prompting them to an initiative over and above that required to walk through a gallery and contemplate the pictures on the walls. His simplest tactile sculptures are the plug-in pictures, and the spring steel reliefs that can be played like musical instruments. In the former, however, one static state simply replaces another, while in the latter the vibrating elements eventually return with time to their original position.

Agam's post-1966 "transformables" go much farther. The artist calls them "instruments to create an unlimited number of space." The first of these were game-like sculptures of bronze or stainless steel. *Moods*, to name one (pages 60, 61), consists of nine semicircles of increasing size set perpendicularly to one another; they can be put together, pulled apart, stood on edge or set in movement, manipulated in any way one's mood suggests—hence the title—and the possibilities are unlimited. *Double Triangle* (page 56, at right) is similar, with its optical illusions, strange perspectives and structures in space. And Agam's *Thousand Gates Twice*, shaped like hurdles, can be set up at any interval one chooses.

These congeries of shapes can be used to create tectonic forms when they are repeated and heterogeneous ones when they are disjoined, in contrast to two other groups of works which are mounted on free-standing bases. One group, which includes *Touch Me*, *Couple* and *All Directions* (page 58), uses rods mounted in parallel on a base, some bent slightly, some sharply, which can be set to converge or diverge in sequences which remain purely linear. The second group uses rods which, bent in more than one place or twice at right angles, form variable spatial constellations when they are manipulated. Among these are *Line—Volume* (page 63), *The Eighteen Levels* (pages 53, 54) and *Three Times Three* (page 57). The game-playing aspect seems paramount in most of the pieces in the first group, whereas the second group are truly sculptures in the sense that they define space anew with each new positioning of their elements.

Beyond Constructivism

With these works Agam places himself in the tradition of Constructivist sculpture since Tatlin, sculpture that, instead of displacing space by introducing compact volumes into it, makes use of open form and transparent material to create an inter-

page 48: (Above) Infinite Transparency, Cleveland 1971
(Below) Accessible and Transformable Wall, Montpellier 1971
page 49: Elysée Salon, Paris 1972

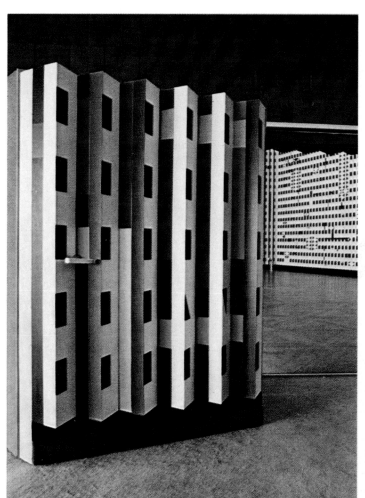

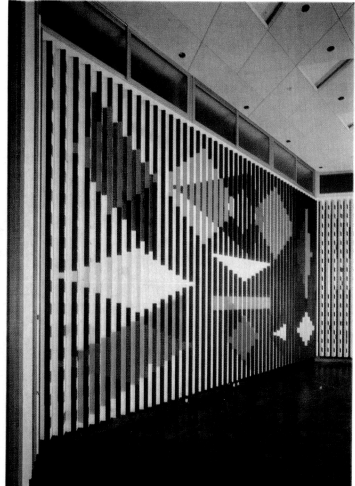

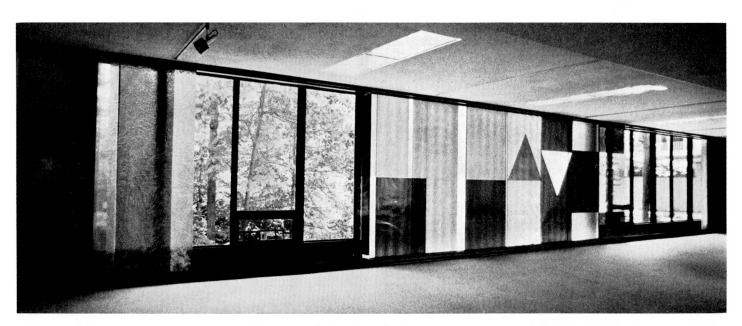

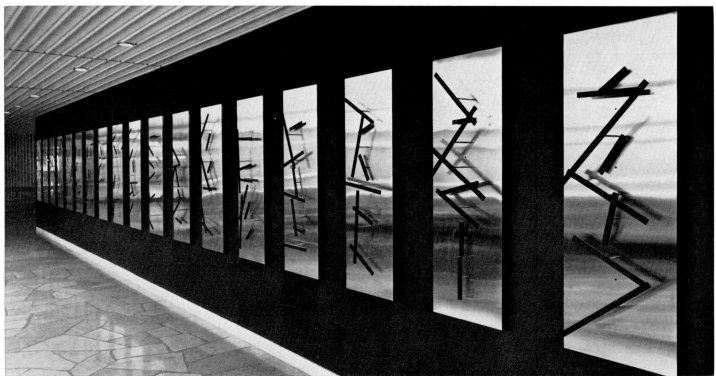

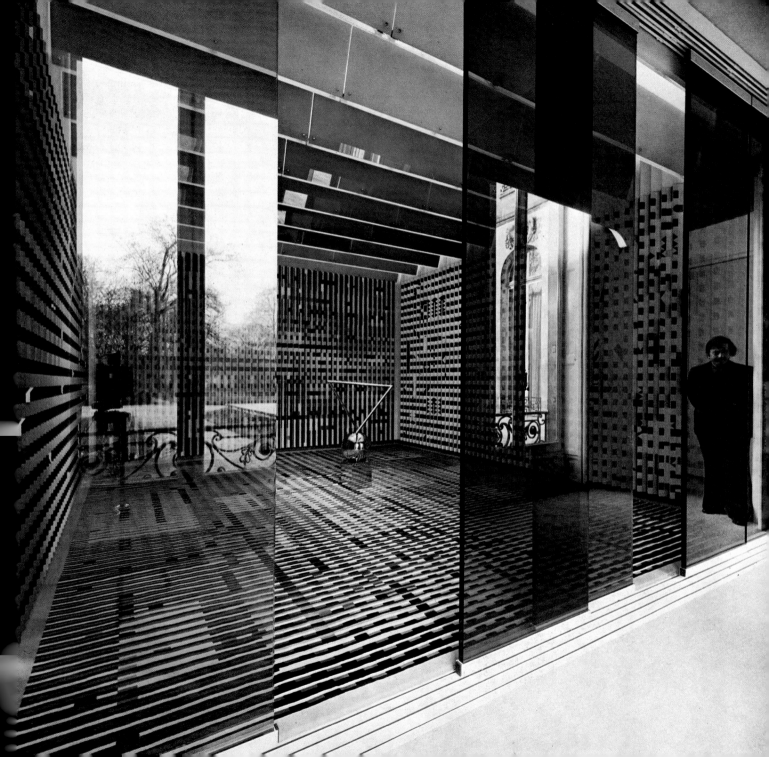

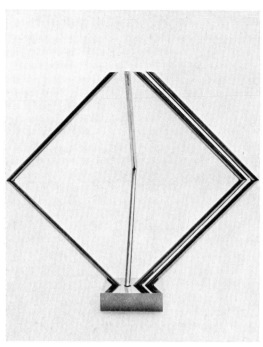

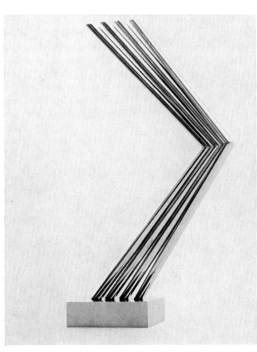

penetration of space and mass. Naum Gabo and Antoine Pevsner used plexiglass, wire and taut thread to let in space and light, and polished the surfaces of their sculptures to the anonymity of industrial products in order to purge their art of all traces of subjectivity that might interfere with the play of natural forces. Laszlo Moholy-Nagy's *Light-Space Modulator* created wholly new sculptural frames of reference by means of rotating reflecting surfaces and light sources. Picasso, Gonzàlez, Giacometti and David Smith, on the other hand, lent their space-cage sculptures a certain rough-hewn look, definitely appealing to sensibilities schooled in Surrealist association.

But what the work of these artists, that of Alexander Calder, César Domela and Norbert Kricke, and even the wind-driven oscillating pointers of George Rickey, do not have is the uniformity of elements so characteristic of Agam's work. Varying his sculptural elements only in size, Agam takes up in sculpture the same problems he deals with in his painting, translating the lines of force of optical schemata into three-dimensional terms. What in a painting can only be an illusion, namely the converging and diverging movement of shapes and lines, is a reality in sculpture. Here, too, Agam makes good use of the spatial uncertainty created by repeated lines and the restlessness of the eye as it jumps from one version of the gestalt to another. *Thousand Gates* (page 55) is a superb example of this, as is *The Eighteen Levels* (pages 53, 54), in which a diagonally ascending ladder—a truly Agamic symbol—evokes even in repose an additional perceptual uncertainty, an illusion of space.

With these "transformables," on the theme of the transience of the gestalt experience and the intoxication of spatial perception, Agam has built up an arsenal of sculptural form that often works to best effect in an architectural context. Sculpture in public places need not be pompous or monumental, as Agam's linear, immaterial pieces show, pieces like the wind-harps with their moving polished pipes sparkling in the sun.

Agam's ethereal, playful sculptures are working their magic in a number of urban situations: in the schoolyard of the Lycée Mixte in La Roche-sur-Yon (page 59), in front of the Julliard School of Music in New York's Lincoln Center (page 57), as a huge toy in the Botanical Gardens at Vincennes (page 63); *The Eighteen Levels* marks the entrance to the Israel Museum in Jerusalem (pages 53, 54); in the garden of the palace of Israel's President stands *Thousand Gates* (page 55), named after the part of the city with its countless gates and archways.

In every case Agam has successfully projected his small models onto a large scale. Optical structures are subject to the same laws no matter their size; only the viewer's relationship to them changes. Play becomes conscious intent with these large pieces, and the space they take up can be experienced in more detail because we can walk into it. Yet their scale intimidates and works against our desire to manipulate them; their present sculptural aspect tends to hold sway longer over other solutions; the extreme level of activity of Agam's optical painting gives way to calm in his sculpture.

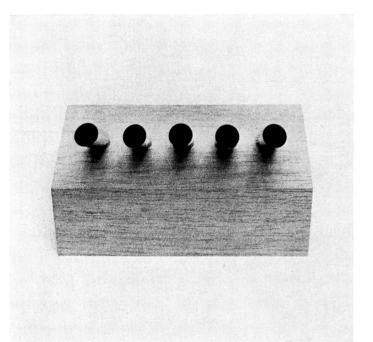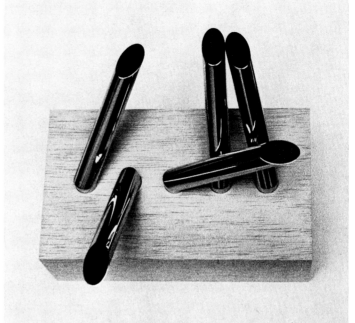

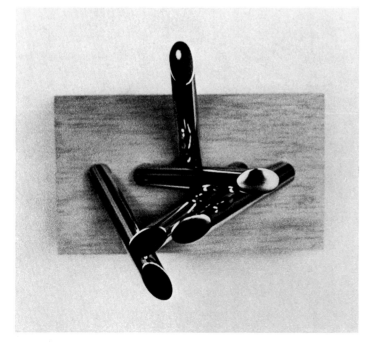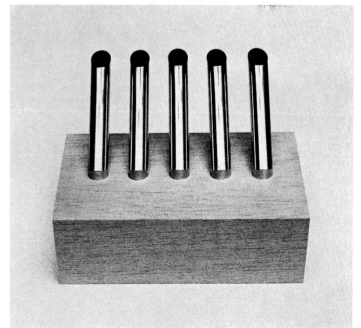

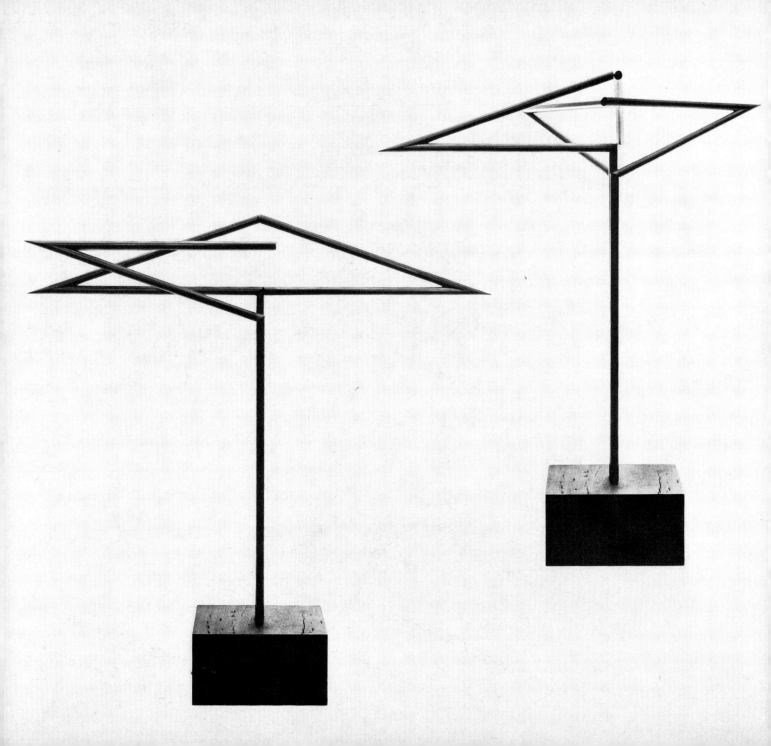

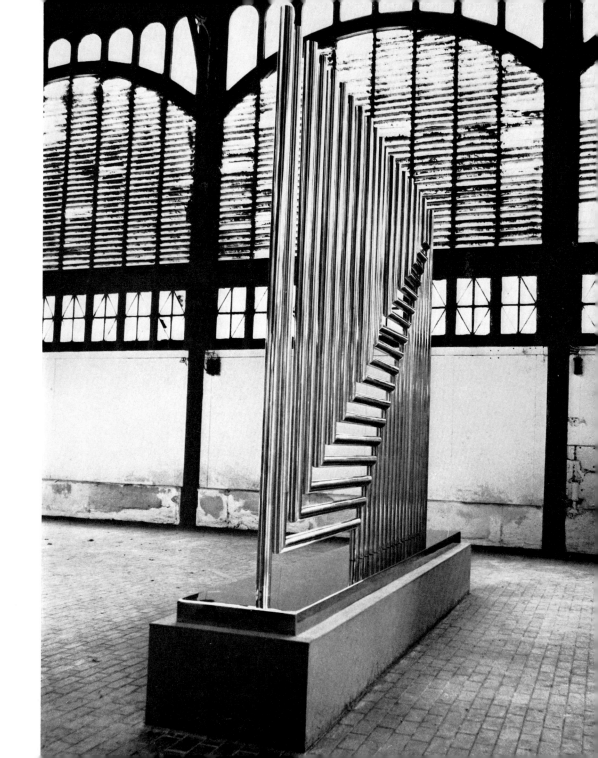

◁ Star of David in Four
Dimensions 1970

The Eighteen Levels 1970 ▷

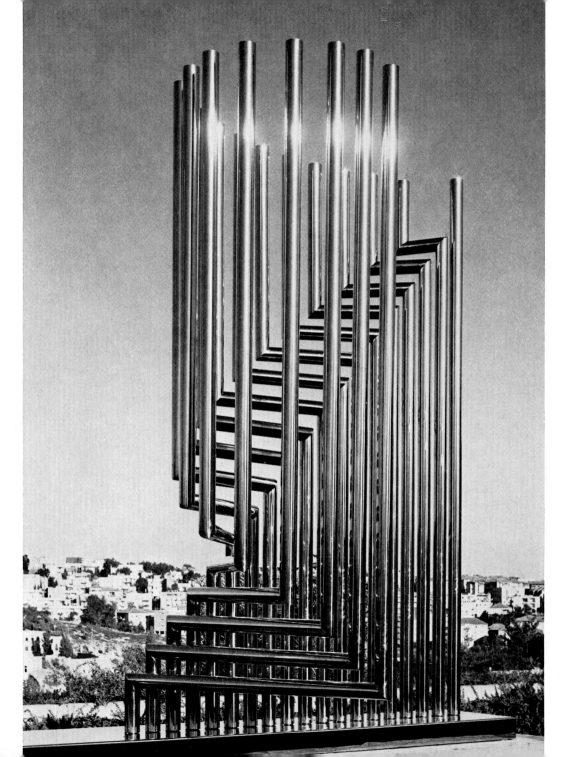

The Eighteen Levels, Jerusalem
1970

Thousand Gates, Jerusalem 1971 ▷

54

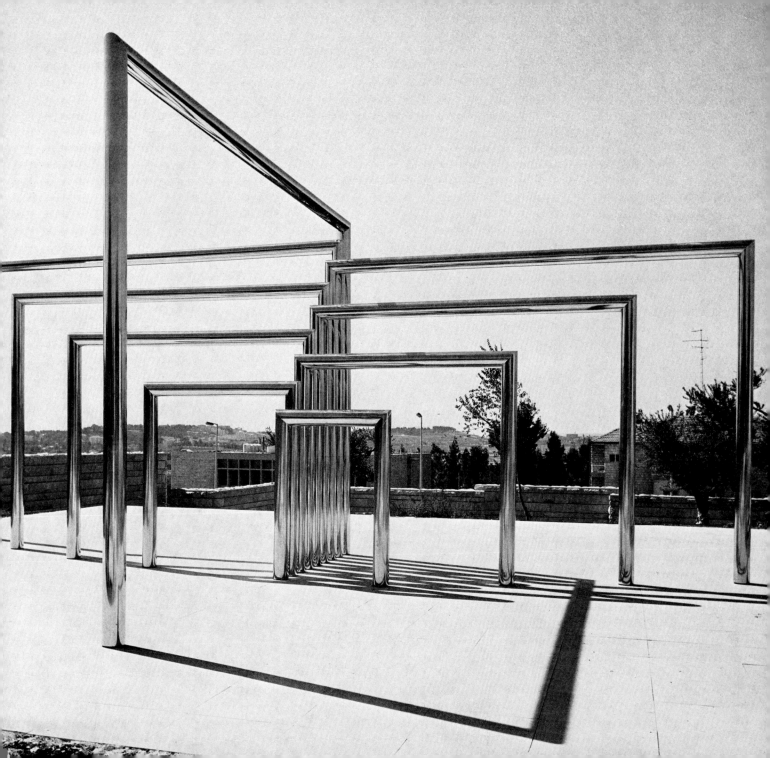

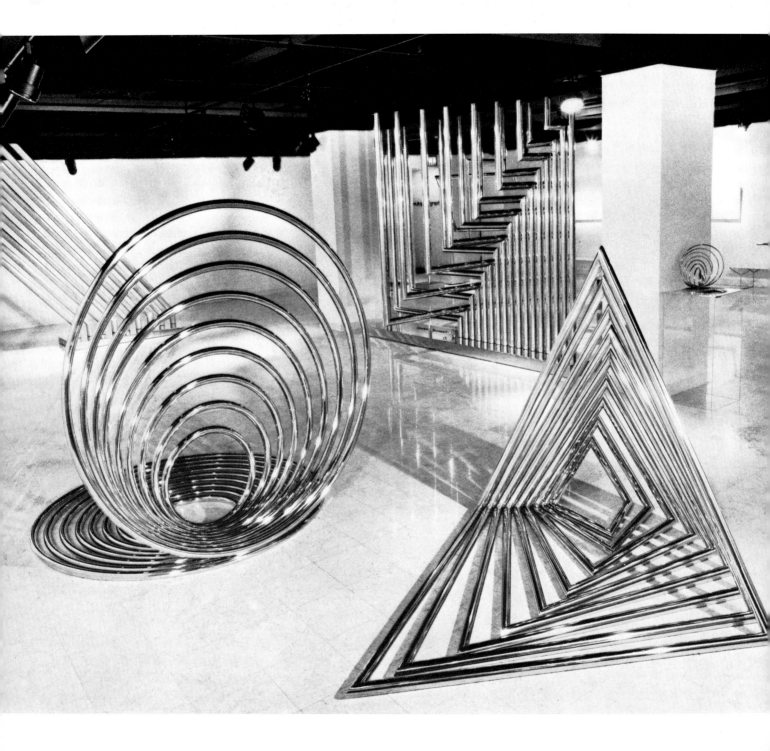

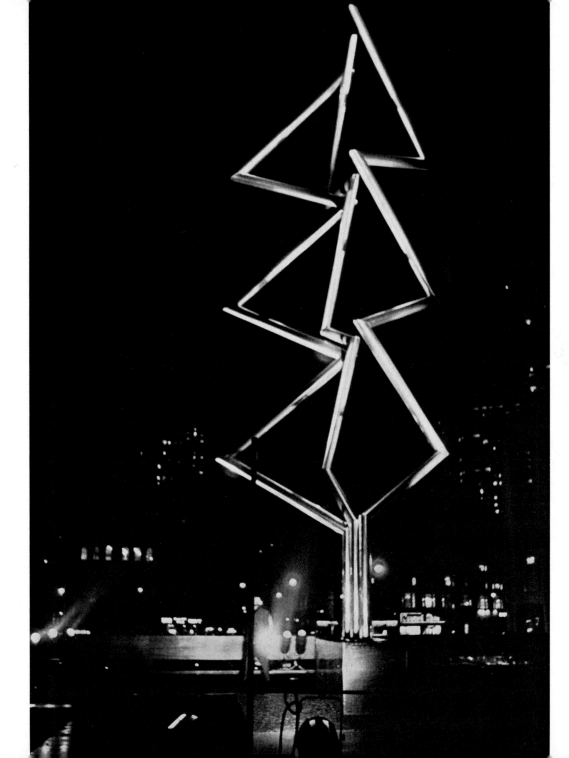

◁ (Left to right)
All Directions 1971
The Ninth Power 1970–71
The Eighteen Levels 1970
Double Triangle 1971
The Ninth Power (Model) 1970–71

Three Times Three,
New York 1971 ▷

page 58: Agam at work
page 59: All Directions,
La Roche-sur-Yon 1971

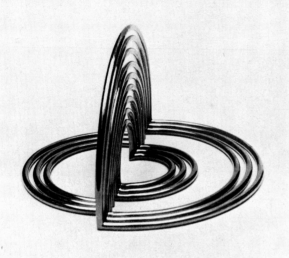

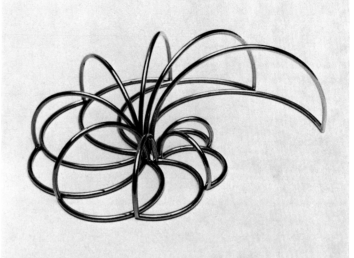

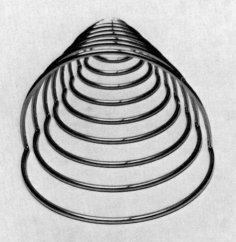

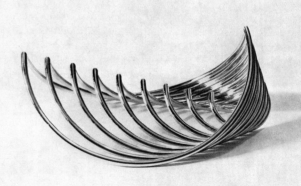

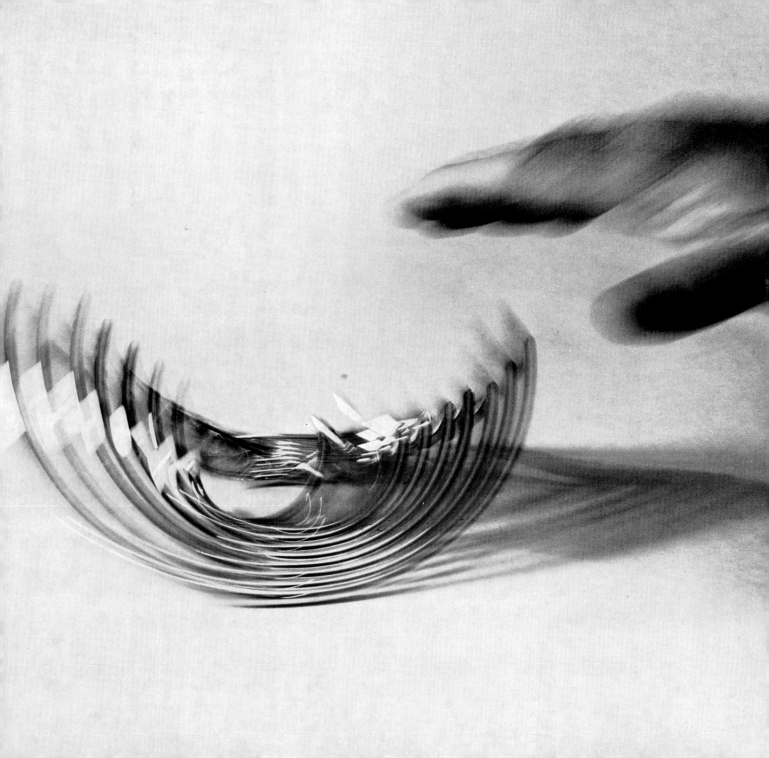

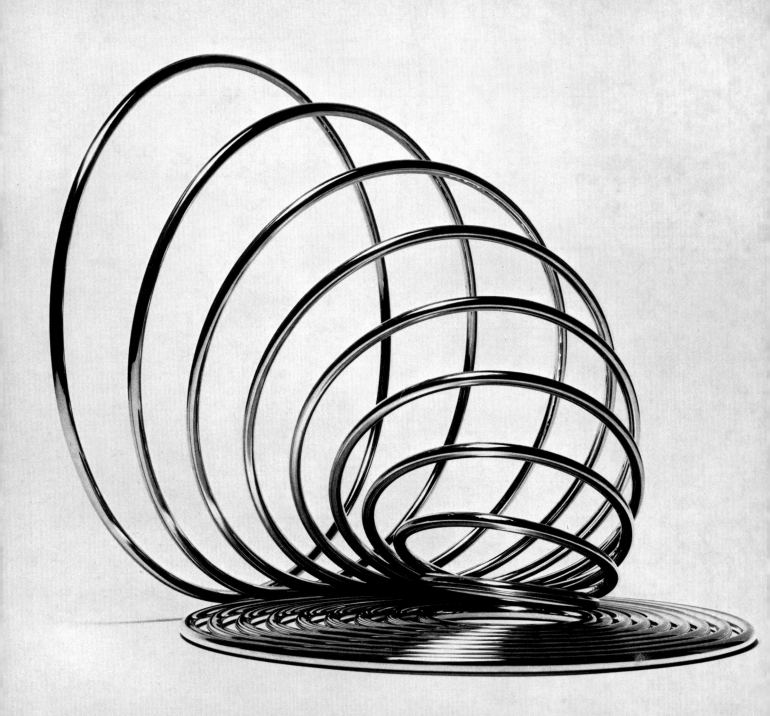

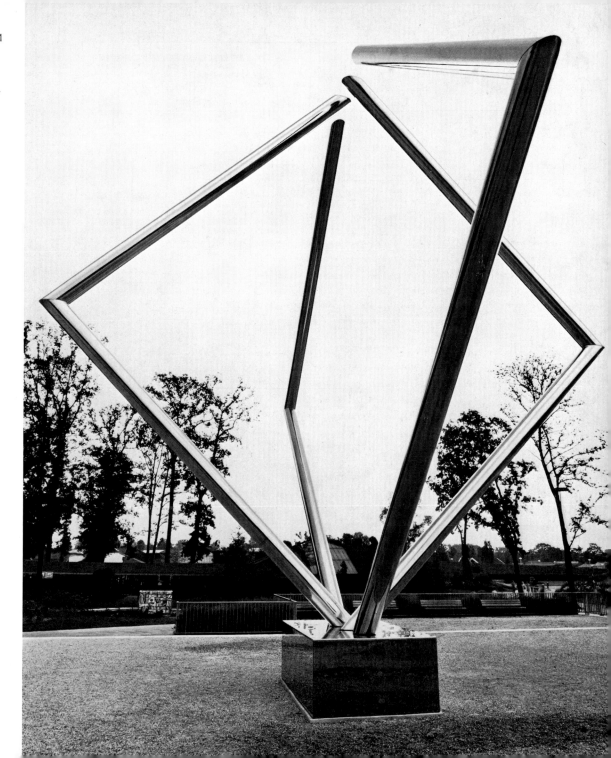

◁ The Ninth Power 1970–71

Line—Volume,
Vincennes 1971 ▷

This balance is characteristic of Agam's art. His painting bombards the retina with images at such a rate that we feel our perception is not to be trusted: in search of illusion, reality remains invisible. The transitoriness of the visible, as he calls it, excites him so much that he invented a soap-bubble making machine: a bubble sculpture (page 66). Worked by hand controls, this piece produces as many bubbles and as fast as anyone could desire, and they float through the room shimmering in rainbow colors until ... pop: an apt metaphor for a world in transition without past.

Agam's experiments in rendering visual the energy of light follow a similar line. For the 1967 exhibition "Lumière et Mouvement" in Paris he set one of his polymorphous paintings in rotation and bathed it in stroboscopic light. The effects ranged from a complete suspension of movement to complete dissolution of the whirling image in space; by regulating its speed one was free to make the painting disappear at will, like a computer operator by complicated electronic processes. Agam's Utopia aims at freedom and creativity for Everyman. He wants us to "take control of the physical forces surrounding us. This can only be achieved by setting free the powers within us by artistic experiment that is active and that must appeal to all the senses."[17]

Agam sees simple steps to this goal. At the "Lumière et Mouvement" exhibition, the public was invited to step into a white walled space—*espace rythmé*, as Agam called it—and, by speaking softly or loudly, cause a light bulb to flicker or burn brightly. If no one spoke, the room remained dark. *Fiat lux* was Agam's name for this invention, the purpose of which was to set free people's impulses and energies rather than involving them directly in the creation of a work of art (page 67); and Agam's *Tableaux à ficelles* offered the public a handy metaphor for the irreversibility of time by asking them to cut off the pieces of string hanging from the painting.

Anyone can be creative if only he is asked to be—this is the axiom on which Agam bases his definition of the artist as a giver of impulses and agitator to activity. He is ahead of his time in the same sense that art has always been supposed to be ahead of life. Agam turns today's technology to his immediate purposes, true; but his far-reaching aims are the real key to his work, his vision of the future and the role creative imagination is to play in it. This is why he is extremely critical of museums of the traditional kind whose purpose is to preserve the past; he finds them obsolete and irrelevant if not positively oppressive and damaging to sensibility. He is planning a museum that will always be one step or more ahead of its time, that will show the possibilities open to art in the future together with the latest in media technology. Agam's projected museum is a museum of possibilities and probabilities fully in keeping with his ideas for reform in the area of visual education. He argues for a revolution that would make everyone creative and art a positive and ever-present stimulus to life. Only then would art be involved in the same continual process of *becoming* as life, on the same energy level as the human brain, and perhaps everyone would be capable of conjuring up those sculptures of water and fire that Agam has been working on (page 68). They would truly be ever-present, ever-changing, ever-new.

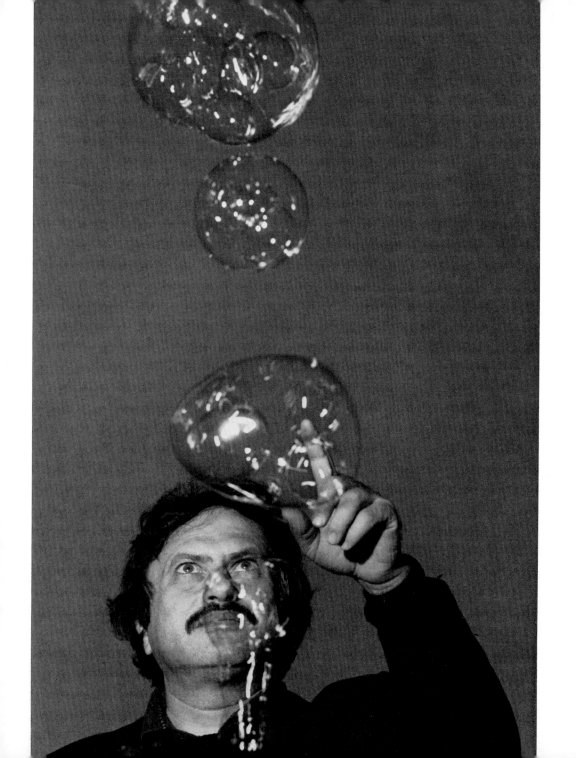

Fiat lux (Let There Be
Light) 1967

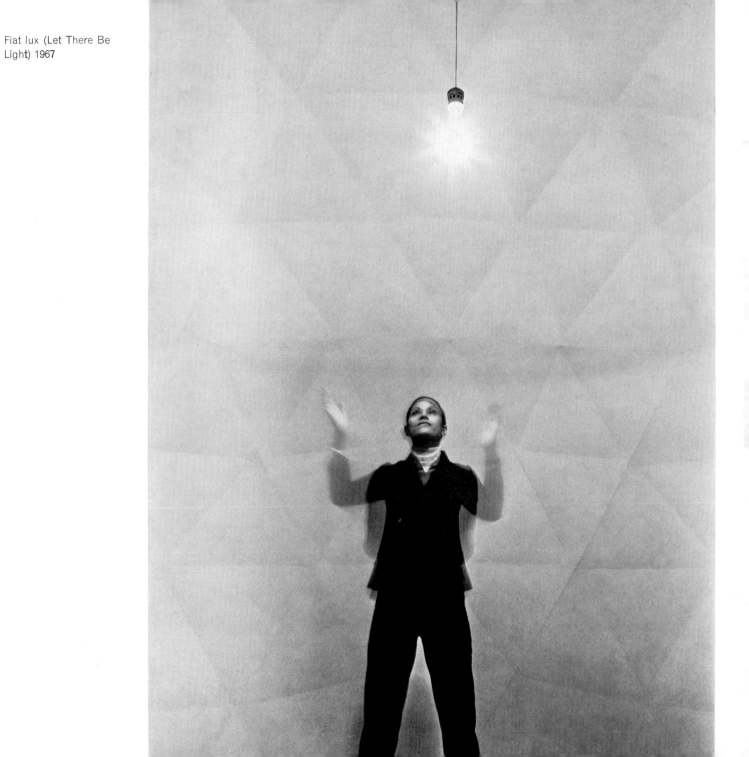

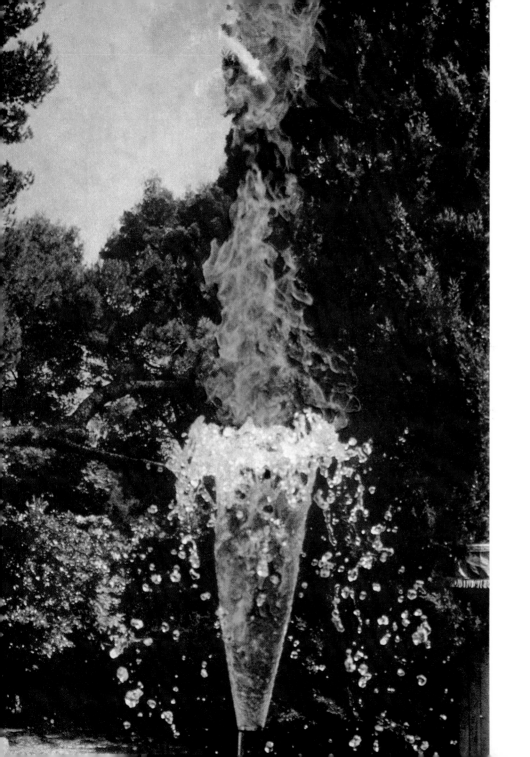

אַחֲרֵי שֶׁהַדָּבָר הַמְקֻיָּם
הוּא כְּבָר אֵינוֹ קַיָּם -
שֶׁכֵּן שׁוּם דָּבָר אֵינוֹ קַיָּם
מִכְּלַל שֶׁהַמְקֻיָּם וְכֹל
קַיָּם מַשֶּׁהוּ אַחֵר צָרִיךְ
לְקַיֵּם.

אָנָּא לְךָ נִתַּן.

Notes

[1] The exhibition was open from 30 October to 12 November. In December 1953, at the Galerie Apollo in Brussels, Pol Bury showed ten *Plans mobiles*, manipulable reliefs made up of geometrical forms. Early in 1954 there followed, at the Galerie Arnaud in Paris, the first motor-driven reliefs by Jean Tinguely. Jesús-Rafael Soto exhibited for the first time at the Salon des Réalités Nouvelles in the same year.

[2] Agam has denounced the tendency to lump optical and kinetic art together. On the occasion of his participation in the exhibition "The Responsive Eye," which William C. Seitz mounted with great success at the Museum of Modern Art, New York, he took particular exception to the following passage in Seitz's catalogue text (p. 9), in which an attempt is made to reduce the whole problem to laconic formulae:

"Perceptual and kinetic art have an intertwined development that cannot be totally disentangled; nevertheless perceptual, optical, or 'virtual' movement—which always exists in tension with factual immobility—is an experience of a different order. Carefully controlled static images have the power to elicit subjective responses that range from a quiet demand made on the eyes to distinguish almost invisible color and shape differences to arresting combinations that cause vision to react with spasmodic afterimages. The countless possibilities of these mysterious phenomena are almost as difficult to enumerate as their psychological and physiological causes are to determine.

"Before the advent of abstract art a picture was a window through which an illusion of the real world could be viewed, and a statue was a replica. Nonobjective painting and sculpture defined a work of art as an independent object as real as a chair or a table. Perceptual abstraction—its existence as an object de-emphasized or nullified by uniform surface treatment, reflective or transparent materials, and a battery of optical devices—exists primarily for its impact on perception rather than for conceptual examination. Ideological focus has moved from the outside world, passed through the work as object, and entered the incompletely explored region area between the cornea and the brain."

[3] See Frank Popper, *Naissance de l'art cinétique*, Editions Gauthier-Villars, Paris 1967.

[4] S. Giedion, *Space, Time and Architecture—The Growth of a New Tradition*. Harvard University Press, Cambridge 1944.

[5] Max Bill, "Die mathematische Denkweise in der Kunst unserer Zeit," *Werk* (Winterthur), March 1949.

[6] Johannes Itten, *Kunst der Farbe—Subjektives Erleben und objektives Erkennen als Wege zur Kunst*. Otto Maier Verlag, Ravensburg 1961.

[7] Serge Lemoine points out the affinity between certain Agam works and those of Sophie Taeuber-Arp; see Serge Lemoine, "La baguette magique," in *Agam (cnacarchives 8)*, Paris 1972, p. 24.

[8] Werner Spies, *Josef Albers*. Thames and Hudson, London, and Harry N. Abrams, New York, 1970, pp. 12, 26.

[9] Jürgen Wissmann, *Josef Albers*. Philipp Reclam jun., Stuttgart 1971, p. 7.

[10] *Agam par lui-même*, Editions du Griffon, Neuchâtel 1962, p. 112.

[11] *Agam par lui-même*, op. cit. (note 10), pp. 9–10.

[12] The Surrealists' assessment of such objects is shown by the following passage from André Breton's programmatic text *Nadja* (1928): "Only a few days ago Louis Aragon drew my attention to the signboard of a hotel at Pourville, on which in red letters appeared the words MAISON ROUGE, in a way and in letters designed so that from one particular oblique angle, when seen from the street, the word MAISON disappeared and ROUGE appeared to be POLICE. This optical illusion would be of no importance if it were not that on the same day, one or two hours later, the lady whom we shall call the Lady with the Glove took me to see a transformable picture such as I had never seen before, which formed part of the furnishing of a house she was renting. This was an old engraving, which, seen from directly in front, shows a tiger; but as it is covered with narrow vertical strips at a right angle to its surface, when one steps a few paces to the left it shows a vase, and when one steps a few paces to the right it shows an angel. I draw attention to these two facts, in conclusion, because in the given circumstances their coincidence for me could not have not taken place, and because it seems to me more than usually impossible to establish a rational connection between them."

[13] *Agam par lui-même*, op. cit. (note 10), p. 5.

[14] Elena de Bertola has worked out a definition of the difference between a painting like *Melody* and static works. Her analysis is contained in her mimeographed doctoral dissertation "Art cinétique. Le Mouvement et la transformation: analyse perceptive et fonctionnelle," Paris 1971, p. 71 ff.: "*Melody* reveals itself to me primarily as a metamorphosis. Over the entire time sequence I have no complete work before me, but one continually in process of becoming. A comparison of such changeable reliefs with 'static' reliefs and sculptures reveals in the latter a constancy of form and color on a static unmoving object. Of course I can call up different retinal images by moving my eyes or walking around the piece, but all of this information relates to an unchanging object in which the pieces come together to form a static whole.

"Think now of a variable piece like the one by Agam mentioned above. What do we perceive immediately, and without movement? A static whole, a juxtaposition of parallel reliefs ... But at the slightest movement we make to see the work as a whole, we immediately notice a change in the material quality of the piece itself.

"The anamorphoses, used often in Renaissance art, can be seen as early forebears of transformable works of this kind."

[15] Agam compares the continual appearance of new images on this ceiling with the prophecies so pervasive in the history of the Jewish people. Yaacov Agam, "On two of my recent works," *Art International* (Lugano), vol. IX, no. 6, 1965.

[16] See the chapter "Projekt eines Theaters mit mehreren Bühnen in Kontrapunkt," in *Agam par lui-même*, op. cit. (note 10), pp. 117–120. See also Jacques Poliéri, *Scénographie nouvelle*, special issue of *Aujourd'hui* (Boulogne-s.-Seine), no. 42–43, October 1963. Stage productions by Jean-Louis Barrault *(Rabelais)*, Luca Ronconi *(Orlando furioso)* and Peter Stein *(Peer Gynt)* have all recently contributed solutions to this problem without making any attempt, however, to suggest a design for a totally new kind of theater complex. *Orlando furioso* (after Ariosto), for instance, would adapt well for itinerant companies interested in presenting simultaneous theater in factories, market halls or stadiums.

[17] Frank Popper, "Agam's Tele-Art," *Art and Artists* (London), vol. IV, no. 10, January 1970, p. 54.

List of illustrations

69 × 90 cm (27$^1/_4$ × 35$^1/_2$ in)
William Benenson collection, New York

22–23 Spatial Relief 1959
Painted metal parts soldered on to adjustable rods
60 × 120 × 60 cm (23$^5/_8$ × 47$^1/_4$ × 23$^5/_8$ in)
Collection of the artist

24 Stages of Creation 1961
Oil on wooden relief
22 × 30 cm (8$^5/_8$ × 11$^3/_4$ in)
Mme Pierre Faucheux collection, Paris

25 Four Themes, Counterpoint 1959
Oil on wooden relief
90 × 121 cm (35$^1/_2$ × 47$^5/_8$ in)
Samuel Dubiner collection, Israel

26 (Above left, below left and right)
Sensibility 1961
Tactile painting
Polychrome parts on springs; the slightest touch sets them in motion; on wooden board
207 × 290 cm (81$^1/_2$ × 114$^1/_8$ in)
Modarco collection, London

26 (Above right)
Sonore 1961
Tactile painting with acoustic effects
Movable metal plates with sound sources on a wooden sounding-board
99 × 139 cm (39 × 54$^3/_4$ in)
Museum Haus Lange, Krefeld

27 Evolution, White, Black, Color 1963
Transformable, sliding painting
Oil on wood
45 × 108 cm (17$^3/_4$ × 42$^1/_2$ in)
Recanati collection, New York

28–29 Double Metamorphosis II 1965
Polymorphic painting
Oil on metal
290 × 435 cm (114$^1/_8$ × 171$^1/_2$ in)
The Museum of Modern Art, New York, Mr. and Mrs. Georges Jaffin Foundation

30–31 Homage to Johann Sebastian Bach 1965
Metapolymorphic painting
Fugue in 9 different compositions
Oil on wood
72 × 153 cm (28$^3/_8$ × 60$^1/_4$ in)
Peter Stuyvesant Foundation, Zürich

32–33 Time Step 1971
Polymorphic wall

Oil on aluminum
450 × 630 cm (177 × 248 in)
Tel Aviv Museum, Mr. and Mrs. Morris A. Lipschultz Foundation, Chicago

34 Rhythmic Relief 1964
Polymorphic painting
Assemblage of triangular wooden parts; oil on wood
42 × 42 cm (16$^1/_2$ × 16$^1/_2$ in)
William Benenson collection, New York

35 Painted Columns 1963–64
Rhythms in white-and-black (left 1,2)
76 × 3.2 × 5.5 cm (30 × 1$^1/_4$ × 2$^1/_8$ in)
Color accents (right 3–6)
56 × 3.2 × 5.5 cm (22 × 1$^1/_4$ × 2$^1/_8$ in)
Oil on aluminum
Private collection

36–37 Jacob's Ladder (Maquette) 1964
3 views: top seen from above, centre and bottom seen from the side
Oil on wood
9.6 × 99 cm (3$^3/_4$ × 39 in)
E. Dobkin collection, Jerusalem

38–39 Jacob's Ladder 1964
Acrylic on concrete
90 × 3.6 m (300 × 12 ft)
National Convention Center, Jerusalem

41 New Year 1967
Metapolymorphic painting
Oil on aluminum relief
81 × 103 cm (31$^7/_8$ × 40$^1/_2$ in)
Mrs. Victor Loeb collection, Berne

42 (Above) Multi-stage Theater (Project) 1962
Section

42 (Below) Leverkusen Forum 1970
Ground plan of the Agam room

43 Leverkusen Forum, Agam Environment 1969–70
Six polymorphic walls, each 5.40 × 10 m (18 × 33 ft)
For comparison of magnitude see grand piano in background

44–45 Leverkusen Forum
At the inauguration in April 1970, fom left to right: Rolf Wedewer, director of Museum Leverkusen, Schloss Morsbroich, Ben-Horin, Israeli ambassador in Bonn, Agam, and Willy Kreiterling, cultural director of the town

47 Leverkusen Forum
Left: An open entrance door of the Forum
Right: The closed door is perfectly integrated in the decoration of the wall

48 (Above) Infinite Transparency 1971
Sliding panels of colored plexiglass
3 × 24 m (10 × 80 ft)
Park Synagogue, Cleveland, Ohio

48 (Below) Accessible and Transformable Wall 1971
8 + 1 in movement: 18 "qualitative" permutations
Polished stainless steel panels, movable parts in black anodized aluminum, polychrome on reverse, mounted on steel rods
2.70 × 27 m (9 × 90 ft)
Faculty of Science, Montpellier University

49 Elysée Salon 1972
Walls oil on aluminum
Composition of more than 900 different colors
6 sliding translucent polychrome acrylic panels
Carpet, sculpture
Palais de l'Elysée, Paris

50 Line—Volume 1970
Transformable sculpture
Stainless steel
Height: 30 m (100 ft)
Edition $^1/_9$ to $^9/_9$
Centre National d'Art Contemporain, Paris

51 Fingers 1968
Transformable sculpture
Chrome-plated steel parts on base of Balsa wood
30 × 18 × 18 cm (11$^3/_4$ × 7 × 7 in)
Mr. and Mrs. William Tannenbaum collection, Chicago

52 Star of David in Four Dimensions 1970
Transformable sculpture
Stainless steel on wooden base
Width: 45 cm (17$^3/_4$ in); diameter of individual parts: 9 mm ($^3/_8$ in)
Mr. and Mrs. Harold Ruttenberg collection, Jerusalem

53–54 The Eighteen Levels 1970
Transformable sculpture
Stainless steel

3×4 m (10×13 ft)
Israel Museum, Jerusalem

55 Thousand Gates 1971
9 movable gates, stainless steel on white marble
Width: 9 m (30 ft); height: 3.90 m (13 ft);
length: 4.50 m (15 ft)
Presidential Palace, Jerusalem

56 Agam exhibition at Denise René Gallery, New York, May, 1971
(Left to right:)
All Directions 1971
9 movable parts of stainless steel
Height: 3 m (10 ft)
The Ninth Power 1970–71
Stainless steel
144×144 cm (56⁵/₈ in × 56⁵/₈ in)
The Eighteen Levels 1970
Stainless steel
300×400 cm (118×157¹/₂ in)
Double Triangle 1971
Stainless steel
144×144 cm (56⁵/₈×56⁵/₈ in)
The Ninth Power (Maquette) 1970–71
Stainless steel
36×36 cm (14¹/₈×14¹/₈ in)

57 Three Times Three 1971
Transformable sculpture
Stainless steel
Height: 11 m (36 ft)
Julliard School of Music, Lincoln Center, New York
Mr. and Mrs. George Jaffin Foundation, New York

58 Agam at work on the following sculptures:
All Directions, The Ninth Power, Open Room, Line—Volume
Paris 1970

59 All Directions 1971
Transformable sculpture
Matt stainless steel
Height: 9 m (30 ft)
Lycée Mixte, La Roche-sur-Yon, Bretagne

60–61 Moods (Beating Heart) 1969
Transformable sculpture
9 parts of stainless steel
8×15×19 cm (3¹/₈×5⁷/₈×7¹/₂ in)
Edition ¹/₉ to ⁹/₉

62 The Ninth Power 1970–71
Stainless steel
45×45 cm (17³/₄×17³/₄ in)
Diameter of individual parts: 9 mm (³/₈ in)
Private collection

63 Line—Volume 1971
Transformable sculpture
Stainless steel
Height: 9 m (29¹/₂ ft), Base: 54×120×90 cm (21¹/₄×47¹/₄×35¹/₂ in)
Parc Floral, Vincennes
Property of French Republic

65 Appearances 1956
Perforated plaster surface, light-sources
52×60×12.3 cm (20¹/₂×23⁵/₈×4⁷/₈ in)
M. and Mme. J. Attali collection, Paris

66 Homage to the Pyramides 1972
Device for the production of pre-programmed soap bubbles (with soap bubbles in soap bubbles); distance, size, sequence regulated and with remote-control
Control unit 47×46×46 cm (18¹/₂×18×18 in)
Private collection

67 Fiat lux (Let There Be Light) 1967
Spherical tetrahedral structure: Pierre Faucheux
Electronic system to transform sound waves into electromagnetic waves which control the light
Exhibitions: "Lumière et Mouvement," Musée d'Art Moderne de la Ville de Paris, 1967; Retrospective exhibition "Yaacov Agam," Musée National d'Art Moderne, Paris, 1972
Collection of the artist

68 Water-Fire Sculpture-Fountain 1971
Variable jets of flame and water, programmed and electronically controlled
Collection of the artist

Biography

3

In order to obtain a residence permit for foreign students he registered at the Atelier de l'Art Abstrait of Jean Dewasne and Edgar Pillet at the Académie de la Grande Chaumière. Robert and Nina Lebel introduced him to Surrealist circles and he began attending their meetings regularly.

1953 Finished his first polyphonic paintings and had his first show, at Galerie Craven in Paris. The Surrealists began to show an interest in his work; Max Ernst bought his transformable painting *Signs for a Language*. Michel Seuphor wrote in *Art d'Aujourd'hui*: "Here is a painter of rare modesty: he does not force his standpoint on the viewer but invites him to join in the game and choose his own viewpoint."

1954 Showed three large movable pictures at the Salon des Réalités Nouvelles.

1955 With Soto, Pol Bury and Tinguely he showed work at the "Le Mouvement" exhibition, Galerie Denise René, Paris.

1956 Married Clila, a girl from the town of Rehavot, which is only a few kilometers from Richon el Zion and was founded by his grandfather.

1957 Cinematographic studies *(Le Desert chante)*.

1958 Birth of his first son, Ron.
Simultaneous writing.

1959 First plans and research for a simultaneous theater.

1960 Designed a keyboard instrument to produce paintings.
Furnished a studio for himself at 26, rue Boulard.

1961 Musical experiments. Developed a radio with multiple receiver channels. *Baguestableaux (Ring Paintings)*, sound painting, etc.

1962 Built a record turntable with multiple pickup arms.

1963 Birth of his second son, Orram.
Received the São Paulo Biennale prize for artistic research.

1964 Practiced deep-sea diving in Saint-Tropez. Decorated the lounge of the Israeli passenger ship Shalom.

1965 Executed the ceiling painting at the National Convention Hall in Jerusalem.

1967 First sculptures.

1968 Appointed professor at Harvard University, Carpenter Center.
First stainless steel sculptures.

1969 His daughter Orrit is born.

1970 Environment for Forum Leverkusen, Germany.

1971 New graphic technique: Agamographie. Water-fire sculpture in St. Louis, Missouri. Transparent wall and tabernacle at Park Synagogue in Cleveland, Ohio. Monumental sculptures for the Parc Floral in Vincennes, France, and for the residence of the Israeli State President in Jerusalem.
Awarded the *Prix de la palette d'or* at the international festival in Cagnes-sur-Mer.

1972 French President Georges Pompidou commissioned Agam to do an environment for the Palais de l'Elysée. Kinetic wall for the Faculté des Sciences de Montpellier. Comprehensive retrospective exhibition at the Musée National d'Art Moderne, Paris.

1973 The retrospective exhibition moves to the Stedelijk Museum, Amsterdam, the Städtische Kunsthalle, Düsseldorf, and the Tel Aviv Museum (attended by over 200,000 people).

1974 Designed two walls for American Telephone and Telegraph Company in New York, and a gobelin for the Palais de l'Elysée in Paris; the gobelin was executed by Manufacture de la Savonnerie, Paris. Awarded *Chevalier de l'Ordre des Arts et Lettres*.

1975 Completed monumental sculptures for the Quartier de la Défense in Paris. Monumental sculpture (12 meters high) for the Faculté des Sciences in Dijon. Awarded the degree *Doctor Philosophiae Honoris Causa* by the University of Tel Aviv, together with Eugène Ionesco.

Exhibitions

One-Man Exhibitions

1953 Paris, Galerie Craven. First exhibition of the twenty-five year old Agam's work, a first in the history of art in the sense that it consisted of a series of 45 mobile paintings, of a breadth of variation that was to be a never-ending source for his future work

1956 Paris, Galerie Denise René

1958 Brussels, Galerie Aujourd'hui, Palais des Beaux-Arts
Paris, Galerie Denise René
Tel Aviv Museum

1959 London, Drian Gallery
Zürich, Galerie Suzanne Bollag

1962 Zürich, Galerie Suzanne Bollag

1966 New York, Marlborough-Gerson Gallery

1969 Haifa, Goldman's Gallery

1971 New York, Galerie Denise René. Opening of the gallery with Agam's first exhibition of sculptures: "Transformable Transformables"

1972 Paris, Musée National d'Art Moderne (Retrospective)
Paris, Galerie Denise René (œuvres graphiques)

1973 Amsterdam, Stedelijk Museum
Düsseldorf, Städtische Kunsthalle
Tel Aviv Museum
Newport Beach, Bird's Eye View Gallery
Bourges, Maison de la Culture
Los Angeles, Hebrew Union College, Skirball Museum
Anvers, Centre Romi Goldmuntz

1974 Paris, Galerie Attali: "Oeuvres inédites sur bandes vidéo"
Houston, Texas, Hooks-Epstein Galleries

1975 Paris, Centre Rachi: "Suite Agam"
New York, Jewish Museum: "Agam: Selected Suites"
Pontoise, Musée

1976 Mexico City, Instituto Nacional de Bellas Artes: "Pinturas Esculturas y Otras Tecnicas Artisticas"
Birmingham, Museum of Art
Palm Springs, Palm Springs Desert Museum

Principal Collective Exhibitions

1954 Paris, Musée d'Art Moderne de la Ville: "Salon des Réalités Nouvelles." The three large kinetic paintings arouse the interest and curiosity of the critics
1955 Paris, Galerie Denise René: "Le Mouvement." Agam showed 18 pieces in this show, which was arranged together with Bury, Calder, Duchamp, Mortensen, Soto, Tinguely and Vasarely
1956 Paris, Galerie Furstenberg
Marseille, Unité d'Habitation of Le Corbusier: "Festival d'Avant-Garde" (on invitation of Michel Ragon)
Paris, Musée d'Art Moderne de la Ville: "Salon des Réalités Nouvelles"
Paris, Galerie Creuze: "50 ans de peinture abstraite"
1958 Charleroi, Musée d'Art Moderne: "Art du XXᵉ Siècle"
Pittsburgh, Carnegie Institute: "Pittsburgh International"
1959 Paris, Musée d'Art Moderne de la Ville: "Première Biennale de Paris" (representing Israel)
Leverkusen, Städtisches Museum Schloss Morsbroich: "Denise René stellt aus"
Paris, Galerie Edouard Loeb: "édition mat"
Paris, Galerie XXᵉ Siècle: "Le Relief"
1960 Paris, Musée des Arts Décoratifs: "Antagonismes"
Zürich, Kunstgewerbemuseum: "Kinetische Kunst"
New York, Chalette Gallery: "Construction and Geometry in Painting" (touring exhibition)
Zürich, Helmhaus: "Konkrete Kunst – 50 Jahre Entwicklung"

Paris, Musée d'Art Moderne de la Ville: "Salon Comparaisons"
1961 Amsterdam, Stedelijk Museum: "Bewogen beweging" (also in Stockholm, Moderna Museet, and Humlebaek, Denmark, Louisiana Museum)
Pittsburgh, Carnegie Institute: "Pittsburgh International"
Paris, Grand Palais: "Salon de Mai"
New York, Howard Wise Gallery: "Movement in Art"
1962 Zürich, Galerie Suzanne Bollag
Paris, Galerie Denise René: "Art abstrait constructif international"
Paris, Musée des Arts Décoratifs: "Antagonismes II: l'Objet"
Basel, Galerie d'Art Moderne: "Neue Richtungen in der plastisch-kinetisch integrierten Sichtbarkeit"
Leverkusen, Städtisches Museum Schloss Morsbroich: "Strukturen"
Tokyo and Osaka: "Modern Art of Israel"
1963 São Paulo: VII Bienal de São Paulo (First Prize for Research in Art)
Lausanne, Musée Cantonal des Beaux-Arts: "Premier Salon International des Galeries Pilotes"
1964 Paris, Grand Palais: "Salon de Mai"
Paris, Musée d'Art Moderne de la Ville: "Salon Comparaisons"
New York, Jewish Museum: "Art Israel"
1965 Berne, Kunsthalle: "Licht und Bewegung"
Brussels, Palais des Beaux-Arts: "Lumière, mouvement et optique"
Düsseldorf, Städtische Kunsthalle: "Licht und Bewegung"
New York, The Museum of Modern Art: "The Responsive Eye" (touring exhibition, organized by William C. Seitz; also in St. Louis, City Art Museum, Seattle, Art Museum, Pasadena, Art Museum)
Paris, Galerie Denise René: "Mouvement 2"
Tel Aviv Museum: "Art and Movement"
1966 Eindhoven, Stedelijk van Abbemuseum: "Kunst – Licht – Kunst"
1967 Paris, Musée de l'Art Moderne de la Ville: "Lumière et Mouvement"

Saint-Paul-de-Vence, Fondation Maeght: "Dix Ans d'Art Vivant"
Krefeld, Galerie Denise René / Hans Mayer: "Vom Konstruktivismus zur Kinetik, 1917–1967"
Ottawa, National Gallery of Canada: "Art and Movement" (touring exhibition)
1968 Paris, Musée du Petit Palais: "Israël à travers les âges"
Le Havre, Nouveau Musée, Maison de la Culture: "Art cinétique et espace"
Mexico, Museo Universitario de Ciencias y Arte: "Kineticism"
Grenoble, Maison de la Culture: "Cinétisme, Spectacle, Environnement"
Washington, National Gallery of Art: "Painting in France, 1900–1967" (touring exhibition, also in Boston, Museum of Fine Arts)
1969 Oslo, Kunstnerns Hus: "Visuelt milj. Lys os bevegelse"
Recklinghausen, Städtische Kunsthalle: "Kunst als Spiel"
Saint-Germain-en-Laye, Musée: "De Rodin à aujourd'hui"
1970 Cagnes-sur-Mer: "2ième Festival International de la Peinture" (Agam awarded Première Palette d'Or Prize)
1971 Utrecht, Centraal Museum: "Peter Stuyvesant Stichting"
Tel Aviv Museum: "Art and Science"
Saint-Germain-en-Laye: "Salon de Mai"
Pittsburgh: "International Exhibition"
1972 Paris, Grand Palais: "Douze ans d'art contemporain en France (1960–1972)" (contributed a room environment)
Vitry-sur-Seine: "L'art et les technologies industrielles"
1974 Basel, Galerie Denise René (exhibition at Basel Art Fair)
Newport Beach, California, Bird's Eye View Gallery
1975 Paris, Ranelagh: "La Boule"
Paris, Musée des Arts Décoratifs: "Tapisseries Nouvelles"
Paris, Galerie de la Défense: "La Manufacture de Sèvres"
Lausanne: "7ième Biennale Internationale de la Tapisserie"

Films by and about Agam

1955 *Agam: Oeuvre transformable*. Directed by Agam. Silent, 18 min.

Le Mouvement. Directed by Pontus Hulten and Robert Breer. 15 min. Shown during the Denise René exhibition.

1956 *Recherche*. Film about the work of André Block. Directed by Agam with the cooperation of Arie Mambush. Produced by Pléiade, Pierre Braunberger. Color, sound, 30 min.

1957 *Le Desert chante*. Animated film with original score by Frank Peleg and text by the poet T. Carmi, made with the help of the artist Arie Navon. Directed by Agam with the cooperation of Arie Mambush. Supported by subvention from the Israeli Ministry of Culture. Produced by Madeleine Film, Gilbert de Goldschmidt. Black-and-white, 9 min. French and Hebrew versions.

1959–1960 A series of short animated films directed by Agam.

1966 *Les possibilités d'Agam*. Directed by Warren Forma, New York and Paris. Color, sound. English version.

1968 *Agam meets the computer*. Directed by The Carpenter Center of Visual Art, Harvard University, Cambridge. Program design by Dany Cohen. Black-and-white, silent, 18 min.

1970 *CBS L'art du 21ième siècle*. 55 min.

1971 Film on the erection of the sculpture *Three Times Three* at Lincoln Center, New York. Color, 27 min. Shown at Julliard School of Music and at the "Transformable Transformables" exhibition at Denise René Gallery, New York.

Agam. Directed by Adrian Maben. Produced for French Television by Michel Arnaud. Sound, 10 min.

1972 *Artistes israéliens à Paris*. Directed by Dotan. Produced for Israeli Television. Black-and-white, 9 min., Hebrew.

Agam. Directed by Dotan. Produced for Israeli Television. Black-and-white, 10 min. Hebrew.

1972–1973 *Agam-Image*. Directed by Georges Pessis. Film about Agam's work. Shown at the 1972 exhibition "Douze ans d'art contemporain en France" and at Agam's one-man show at the Musée National d'Art Moderne, Paris.

1972–1975 *Agam*. Directed by Adrian Maben. Film about Agam's work. Filmed in Paris and Israel and at the exhibition at Tel Aviv Museum. Produced by M.H.F. Color, sound, 55 min.

1973 Dutch Television film. 16 mm and video cassette.

German Television film. 16 mm and video cassette.

Pathé-Actualités. 10 min., 16 mm and video cassette.

1974 Ten video productions at Studio Datacommunications, Paris. Directed by Agam.

Transformables lumière et mouvement. 11 min.

Lecture visuelle à travers l'œuvre graphique. 8 min.

L'œil mouvement subtil agamographie. 4 min.

Voyage à travers la peinture polymorphique. 13 min.

Voyage visuel à travers l'œuvre polymorphique. 13 min.

Respiration cosmique. 5 min.

Agam video art electronique. 12 min.

Dialogues formes rythmes electroniques. 12 min.

Images electroniques. 12 min.

Agam tactile. 9 min.

Bibliography

Texts by Yaacov Agam

1958 "Force de gravité et expression picturale," *Aujourd'hui* (Paris), no. 16, March.

Text for exhibition catalogue Galerie Denise René, Paris.

Manifesto for exhibition, Galerie Aujourd'hui, Palais des Beaux-Arts, Brussels.

1960 "Um eine neue Sprache des bildnerischen Ausdrucks," *Nota* (Munich), no. 4.

1961 "Peinture transformable et peinture en mouvement," *Louisiana Revy* (Copenhagen), vol. 2, no. 1, September.

1962 Text for the exhibition "Antagonismes II: l'Objet," Musée des Arts Décoratifs, Paris.

"Alexander Calder en pleine nature," *XXe Siècle* (Paris), XXIV, 26.

1963 "Yaacov Agam propose l'éclatement du temps et de la réalité dans les arts," *La Galerie des Arts* (Paris), no. 8, June.

1964 "The artist and his credo," *Ariel* (Jerusalem), no. 9.

1965 "Conception scénique et conception théâtrale," *Les entretiens sur le théâtre* (Paris), no. 15, November–December.

"On two of my recent works," *Art International* (Lugano), vol. 9, no. 6.

1966 "A flexible theater," *Art in America* (New York), no. 6, November/December.

Text for exhibition catalogue "Kunst—Licht—Kunst," Stedelijk van Abbemuseum, Eindhoven.

Lecture for "International Design Conference," Aspen, Colorado, June 24 (manuscript).

1967 Text for exhibition catalogue "Lumière et Mouvement," Musée d'Art Moderne de la Ville de Paris, and mimeographed statement of May 18.

"La pensée hébraïque inspire l'œuvre de Yaacov Agam," *Arts, la presse nouvelle hebdomadaire* (Paris), March 31—April 6.

1968 "Advance exploration in visual communication." Mimeographed sheets for seminars and courses at Carpenter Center for Advanced Studies in Visual Art, Harvard University, Cambridge, Mass.

1969 "The Jewish conception of art," text for the exhibition "3 Israeli artists: Agam, Lifchnitz, Zaritsky," Whitechapel Art Gallery, London.

1971 "Un art à quatre dimensions," *Preuves* (Paris), no. 7.

1972 The catalogue *Cnacarchives 8. Agam*, published on the occasion of the exhibition at the Musée National d'Art Moderne, Paris, contains the following texts by Agam:
Autobiography;
"Manifeste d'Agam," written for the exhibition at the Galerie Aujourd'hui, Palais des Beaux-Arts, Brussels, 1958;
"Calder," excerpts from "Alexander Calder en pleine nature," 1962;
Excerpts from the monograph *Agam par lui-même*, 1962;
"Le credo de Agam," from *Ariel*, 1964;
"Advance exploration in visual communication," 1968;
Excerpts from "Un art à quatre dimensions," 1971;
"Art and Science—entretien d'Agam et de François Le Lionnais," July 21, 1972 (previously unpublished).

1973 "Je veux apprendre aux enfants l'alphabet de l'image," *Réalités* (Paris), November.

1975 Text for exhibition catalogue "Tapisseries Nouvelles," Musée des Arts Décoratifs, Paris.
Text for exhibition catalogues "The Movement—20 years later" and "Le Mouvement—Vingt ans après," Galerie Denise René, New York/Paris.
"Pour une université de la création," *Galerie—Jardin des Arts* (Paris), July.

Monographs

1962 *Agam par lui-même*. Editions du Griffon, Neuchâtel.

1966 Reichardt, Jasia. *Yaacov Agam*. Methuen, London.

1972 *Cnacarchives 8. Agam*. Published on the occasion of the exhibition "Agam" at Musée National d'Art Moderne, Paris, October 6 to December 4, 1972. Includes texts by Jean Leymarie, Blaise Gautier, Germain Viatte, Jean-Hubert Martin, Serge Lemoin, Frank Popper, François Le Lionnais, Paul Kaniel, and Agam.

1975 Kaniel, Paul. *Yaacov Agam: Transformable Dialogue*. Transworld Art, New York/Fribourg.
Ragon, Michel. *54 mots clés pour une lecture polyphonique d'Agam*. Editions G. Fall. Paris.

1976 Popper, Frank. *Agam*. New York, Harry N. Abrams.

Catalogue Texts

1953 Craven, John. "Agam," preface for exhibition catalogue, Galerie Craven, Paris.

1959 Seuphor, Michel. "Movable and transformable painting," introduction for exhibition catalogue, Drian Gallery, London.

1962 Giedion, Siegfried. "Zum Werk von Yaacov Agam," introduction for exhibition catalogue, Galerie Suzanne Bollag, Zürich.

1963 Gamzu, Haim. Introduction to catalogue on Israel's contribution to the São Paulo Biennale.

1966 Gamzu, Haim. "The metamorphosis of Agam," introduction for exhibition catalogue, Marlborough-Gerson Gallery, New York.

1971 Gamzu, Haim and Levêque, J. J. "Time and space in the work of Yaacov Agam," introduction for exhibition catalogue, Galerie Denise René, New York.

1973 Sandberg, Willem. Poem in the catalogue for the exhibition at Stedelijk Museum, Amsterdam.
Goldman, Jean. Introduction for exhibition catalogue, Maison de la Culture, Bourges.

1974 Ionesco, Eugène. Foreword to *Agam bout à bout*, Editions de Messine, Paris.

1975 Traag, H. van. "Agam, de Schilder van de Tolkommst," Israels Galerie, Amsterdam.

Newspaper and Magazine Articles on Agam

1954 Seuphor, Michel. "Agam," *Art d'Aujourd'hui* (Paris), vol. 4, no. 8.

1955 Bordier, Roger. "Propositions nouvelles, le mouvement, l'œuvre transformable," *Aujourd'hui* (Boulogne-sur-Seine), no. 2, March/April.
Degand, Lêon. "Le mouvement, nouvelle conception de la plastique cinétique," *Art d'Aujourd'hui* (Paris), May.

1956 Hagen, Yvonne. "Agam" *The New York Herald Tribune* (Paris), March 28.
Jouffroy, Alain. "Agam," *Journal des Beaux-Arts* (Brussels), March 21.
Le Lionnais, T. and F. "Une esthétique nouvelle: les œuvres transformables," *Aujourd'hui* (Boulogne-sur-Seine), no. 8.

1958 Gindertael, Roger van. "Agam, zélateur de la peinture en mouvement," *Journal des Beaux-Arts* (Brussels), February 14.
Habasque, Guy. "Agam," *Aujourd'hui* (Boulogne-sur-Seine), no. 18, July.
Hagen, Yvonne. *The New York Herald Tribune* (Paris), May 7.
Ragon, Michel. "Agam," *Cimaise* (Paris), June.

1959 Crosby, Theo. "Agam," *Architectural Design* (London), vol. XXIX, no. 10, October.
Alvard, Julian. "Agam et ses tableaux indépendants du mur," *Aujourd'hui* (Boulogne-sur-Seine), no. 24, December.
Kolb, Eugène. "Agam," *Art International* (Lugano), vol. III, no. 5/6.

1961 Taillandier, Yvon. "Voyage dans un tableau d'Agam," *Aujourd'hui* (Boulogne-sur-Seine), no. 31, May.

1963 Descargues, Pierre. "Connaissez-vous Agam?" *Feuille d'Avis de Lausanne*, January 23.
Jouffroy, Alain. "Yaacov Agam et la peinture instrumentale," *XXᵉ Siècle* (Paris), vol. XXV, no. 22.
Taillandier, Yvon. "Agam et le réalisme de

l'infini," *Art International* (Lugano), vol. VII, no. 5.

1964 Hunebelle, Danielle. "Art en jeu, les inventions d'Agam," *Réalités* (Paris), no. 216, January.

1965 Akiko, Hynga. "Yaacov Agam," *Mizue* (Tokyo), no. 722, April.
Seitz, William C. "Yaacov Agam's double metamorphosis II," *Quadrum* (Brussels), 19, February.

1966 Kramer, Hilton. "Agam, all by himself," *The New York Times*, May 14.
Popper, Frank. "The perceptible absence of the image," *Studio International* (London), July.

1970 Popper, Frank. "Agam's Tele-Art," *Art and Artists* (London), vol. 4, no. 10, January.

1971 Meyer, Jean-Claude. "Agam et le temps retrouvé," *XXe Siècle* (Paris), no. 37, December.
Meyer, Jean-Claude. "Au commencement était Agam," *Combat* (Paris), July 16.
Secrest, Merryle. "Yaacov Agam's Art as Time Experience," *The Washington Post*, May 9.
Taillandier, Yvon. "Les sculptures transformables," *XXe Siècle* (Paris), no. 37, December.

1972 Briat, René. "Les métamorphoses de l'Elysée," *Plaisir de France* (Paris), May.
Ragon, Michel. "Agam—visite d'atelier," *Cimaise* (Paris), no. 108–109, September.
Peppiat, Michel. "Agam," *Art International* (Lugano), vol. XVI/10, December.

1973 Abramowicz Léon. "Agam," *La Galerie—Jardin des Arts* (Paris).
Naggar, Carole. "Anamorphose d'Agam," *Opus International* (Paris).
L.V.W. "De vele dimensies van Yaacov Agam," *New Israelietisch Weekblad* (Amsterdam).
Redeker, Hans. "Agam," *La Galerie* (Paris).
Graevenitz, Antje von. "Sehen im Vorbeigehen – Zur Yaacov Agam-Retrospektive im Amsterdamer Stedelijk Museum," *Süddeutsche Zeitung* (Munich), February 23.
Vrinat Robert. "La magigraphie d'Agam," *Les Nouvelles Littéraires* (Paris).

1974 Adda, Maggy. "Agam," *Perspectives, France-Israël* (Paris).
Perlez, Jane. "Daily close up, inventive art," *New York Post*, July 23.
"Il est triste de ne 'Voir' qu'avec les oreilles," *L'Ecole des Parents* (Paris).
Pompidou, Georges. "S'il doit rester quelque chose de moi, ce sera le salon d'Agam," on October 21, 1974, at the Centre Presse, Poitiers.
Demoriane, Helen. "Agam, le mouvement perpétuel," *Le Point* (Paris), November 11.
Ragon, Michel. "Pour une lecture polyphonique d'Agam," *Nouvelles Littéraires* (Paris), December 2–8.
"Agam Video Art," *La Revue du Liban* (Beirut), December 14.
Barjavel, René. "Agam," *Le Journal du Dimanche* (Paris), December 15.
Saint Bris, Gonzague. "Agam," *Elle* (Paris), December 30.

1975 Tronchet, Anne. "Agam et la video," *Opus International* (Paris).
Parinaud, André. "Un tapis enchanté pour un palais," *La Galerie — Jardin des Arts* (Paris).
Parinaud, André. "Agam et l'histoire du cinétisme: grande aventure de l'art moderne," *La Galerie — Jardin des Arts* (Paris).
Lassaigne, Jacques. "Agam video art," *L'Oeil* (Paris).
Dunoyer, Jean Marie. "Au-delà des apparences," *Formes* (Paris).
Parinaud, André. "Agam, pionnier du multiple dit oui et prophétise," *La Galerie — Jardins des Arts* (Paris).
Parinaud, André. "Agam à l'Elysée," *La Galerie — Jardin des Arts* (Paris).
Bar-Kadma, Emmanuel. "Art en quatre dimensions," *Yediot-Hachronot*.

General Literature

1955 Seuphor, Michel. *Dictionnaire de la peinture abstraite*. Hazan Editeur, Paris.

1959 Seuphor, Michel. *La sculpture de la siècle*. Editions du Griffon, Neuchâtel.

1963 Ragon, Michel. *Naissance d'un art nouveau*. Editions Albin Michel, Paris.

1964 "Yaacov Agam," in *Dictionnaire des Artistes Contemporains*. Les Libraires Associés, Paris.

1966 Bann, S., Gadway, R., Popper, F., and Steadman, P. *Kinetic art*. London. (First publication in book form on kinetic art.)

1967 Kultermann, Udo. *Neue Dimensionen der Plastik*. Wasmuth, Tübingen.
Pellegrini, Aldo. *New tendencies in art*. Elek, London.
Rickey, George. *Constructivism*. Braziller, New York.

1968 Burnham, Jack. *Beyond modern sculpture*. Braziller, New York.
Crispolti, Enrico. *Ricerche dopo l'informale*. Officine Edizioni, Rome.
Popper, Frank. *Origins and development of cinetic art*. Studio Vista, London and New York.

1969 Kultermann, Udo. *Neue Formen des Bildes*. Wasmuth, Tübingen.
Leymarie, Jean. *Depuis 45*. La Connaissance, Brussels.
Smith, Lucie (Ed.). *Movements in art since 1945*. Thames and Hudson, London.
Ragon, Michel. *25 ans d'art vivant*. Casterman, Paris.
Barrett, Cyril. *Op art*. Studio Vista, London.

1970 Huyghe, René, and Rudel, Jean. *L'art dans le monde moderne*. Larousse, Paris.
Popper, Frank. *L'art cinétique*. Editions Gauthier Villars, Paris.

1974 Bordier, Roger. *Peinture contemporaine*. Casterman, Paris.

1974 Ragon, Michel, and Seuphor, Michel. *L'art abstrait*. Vols 3 and 4. Maeght, Paris.

1975 Beer, Joachim François de. *Génie du Judaisme*. Editions Levrault, Paris.

Series Editor: Werner Spies

Translated from the German by John W. Gabriel
Library of Congress Catalogue Card Number:
 74—5115
ISBN 8109—4408—1

Photographers Credit

Agam: 7–9, 11–27, 30/31, 34–37, 41, 48 (above),
49, 51–53, 57, 59–65, 68
Ran Erde, Tel Aviv: 32, 54, 55
Hervé Gloagen, Paris: 28/29, 67
Léon Herschtritt, Paris: 4
Keren-Or, Haifa: 38, 39
André Morain, Paris: 33
Jean-Jacques Morer, Paris: 66
Hans Namuth Ltd., New York: 56, 58
Eric Schaal, Zurich: 43
Holger Schmitt, Leverkusen: 44/45
Claude O'Sughrue, Montpellier: 48 (below)